Sketching With Markers

Thomas C. Wang

 VAN NOSTRAND REINHOLD COMPANY
New York

Van Nostrand Reinhold Company Inc.
115 Fifth Avenue
New York, New York 10003

Van Nostrand Reinhold Company Limited
Molly Millars Lane
Wokingham, Berkshire RG11 2PY, England

Van Nostrand Reinhold
480 La Trobe Street
Melbourne, Victoria 3000, Australia

Macmillan of Canada
Division of Canada Publishing Corporation
164 Commander Boulevard
Agincourt, Ontario M1S 3C7, Canada

16 15 14 13 12 11 10 9 8 7 6

**Library of Congress Cataloging in
Publication Data**

Wang, Thomas C
 Sketching with markers.
 Bibliography: p.
 Includes index.
 1. Dry marker drawing—Technique
I. Title.
NC878.W36 741.2′6 80-27281
ISBN 0-442-26340-6
ISBN 0-442-26341-4 (pbk.)

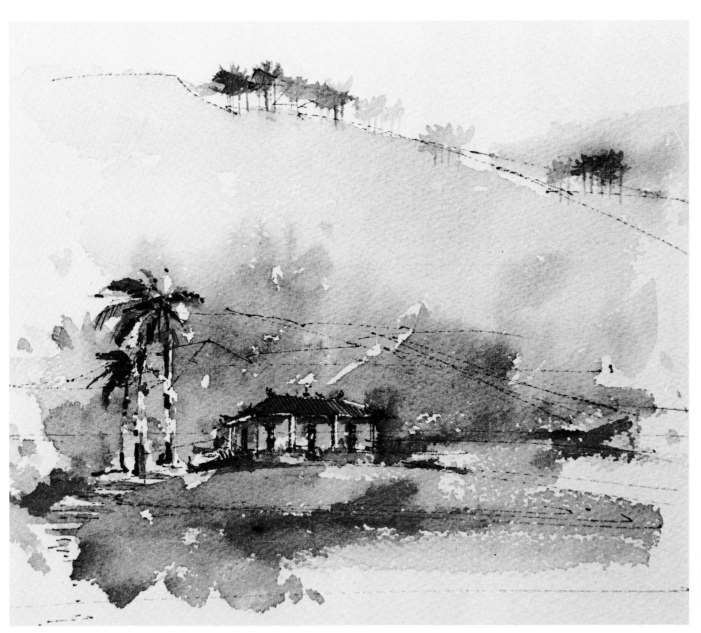

To my son, Joseph

Title: New Territories, Hong Kong
Original Size: 9 x 17 inches
Medium: Pilot razor point and watercolors
Technique: wash

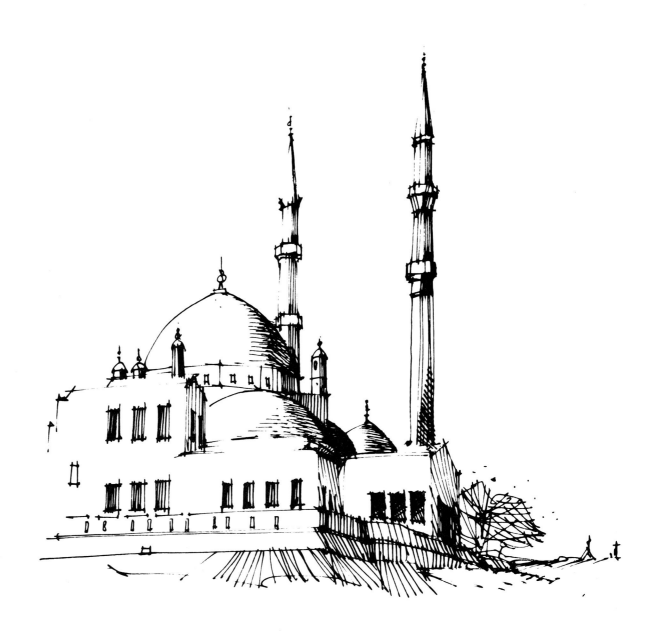

Title: Mohamed Ali Mosque, Cairo, Egypt
Original Size: 8½ x 11 inches
Medium: Pilot razor point on bristol board
Technique: combination of line and line texture

CONTENTS

PREFACE

Markers are probably one of the most popular sketching media. They are versatile, expressive, colorful, and, above all, easy to use. Yet, because of their ability to adapt to a wide range of drawing techniques, markers are still used primarily as a substitute for other traditional sketching media. For example, the fine-point marker can be used to duplicate the performance of an ink pen. Likewise, the rainbow selection of Flair pens is used like an ordinary color-pencil set. Markers tend to be used because of their ease in handling and simplicity, rather than for their uniqueness, construction, and range of nib sizes and inks. This, unfortunately, does not encourage the development of drawing techniques specifically for markers. If this pattern persists, markers may always hold a second-fiddle position to pen and pencil, which have an ancient and respectable heritage.

This book emphasizes the unusual versatility of this remarkable drawing instrument and demonstrates its unique ability to combine its own quality harmoniously with many other media such as watercolor, pen, pencil, and ink. It is my intent to encourage the use and increase the awareness of the marker as a superior sketching tool with unique qualities that can only be expressed thoroughly through the art of sketching.

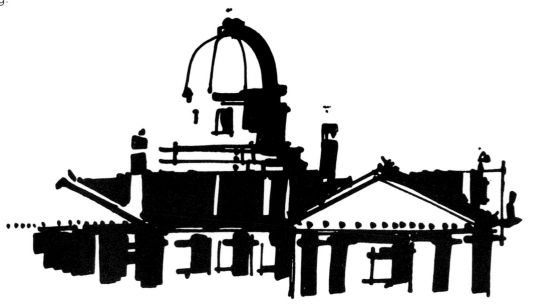

Title: Pioneer Court House, Portland, Oregon
Original Size: 5 x 8 inches
Medium: black label marker
Technique: quick, broad strokes mixed with thinner line by holding the marker at an angle

INTRODUCTION

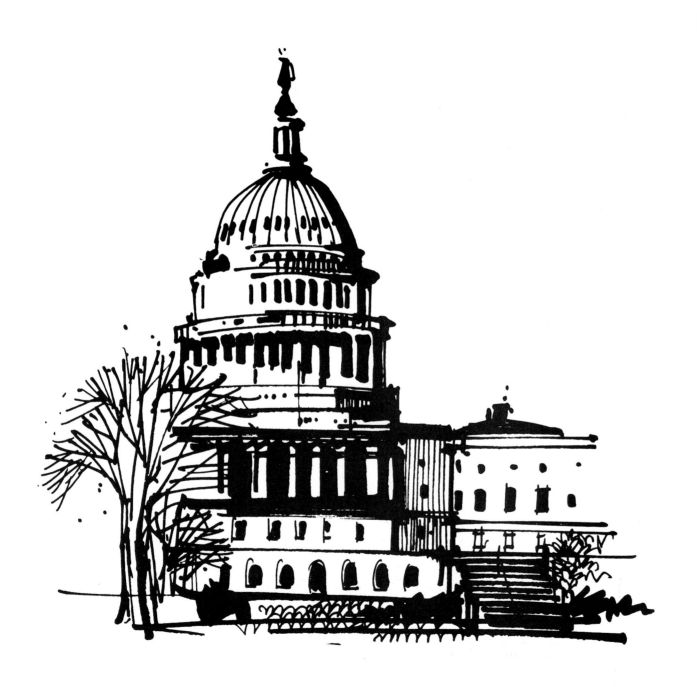

A sketch, by definition, is a rough drawing that represents the chief features of an object or scene. To be more precise, a sketch should accomplish the following:

- capture the essence of an image
- give a simplified version of a complex scene
- provide an abstract graphic description of reality
- create a graphic expression with the minimum amount of lines, tones, and textures
- serve as a quick reproduction process

Title: Washington, D.C.
Original Size: 9 x 13 inches
Medium: black Eberhard Faber (pointed nib) on Aquabee felt-tip marker paper
Technique: quick, semibroad strokes

Perceptual Interpretation

According to Erwin Panofsky (*Studies in Iconology,* Humanistic Themes in the Art of the Renaissance, Icon Editions, 1972), there are two major ways of interpreting perceptual experience: in terms of formal and in terms of factual meaning.

Formal perception is a conglomerate of certain patterns of color, line, and volume that constitutes an image. It captures the silhouette of the image and carries no specific meaning or message. This perceptual experience takes place during the first instant of an entire perceptual sequence. It is followed immediately by factual perception, during which the viewer begins to understand the experience. Factual perception involves identification of certain visible objects known from previous experience, as well as relationships between these objects and cues within the image. Its meaning is often unique to a given culture.

a

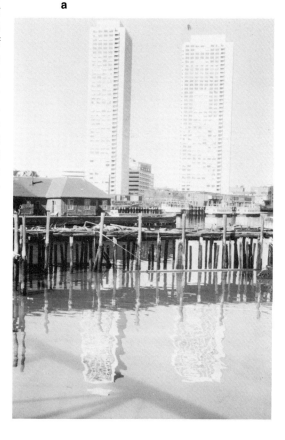

b

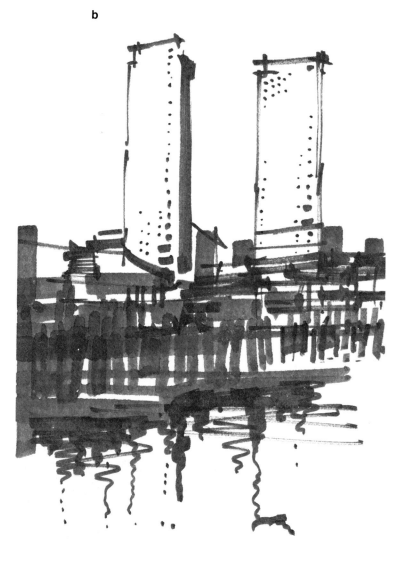

b

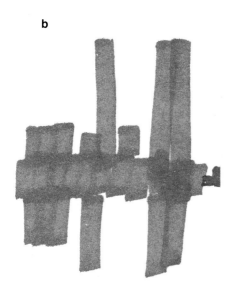

c

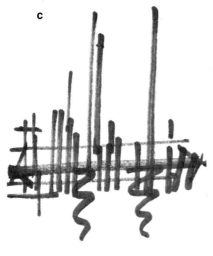

Formal perception can be subdivided into four parts: mass, line, shape, and tone. Mass refers to the figure/ground relationship. It separates the object (mass) from the space (ground). It categorically groups objects that share similar features without differentiating materials, details, and intervening spatial edges (Figure b). Line concerns the predominant orientation(s) of the major structures (Figure c). Shape expresses the character of each object within the picture frame (Figure d), while tone identifies the logical light source and creates the sensation of depth (Figure e).

a

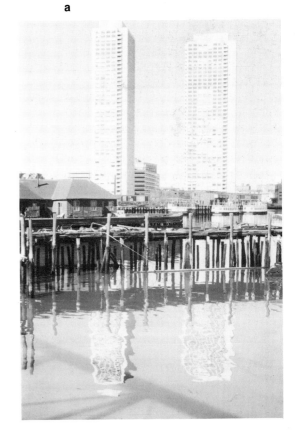

d

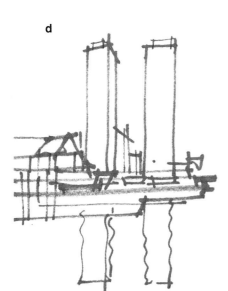

e

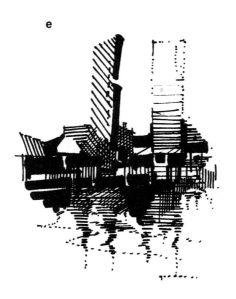

Composition of Identifiable Units

The secondary level of visual interpretation involves subject matter and meaning. These are identifiable components of the image and are located in all three levels of our visual field: foreground, middleground, and background. The position of the viewer determines the degree of complexity of the image and the extent of juxtapositioning. It also determines the size of the picture and it controls the perspective. It is important to learn how to see these components as individual units as well as a totality. The ability to dissect a scene visually and put it back together in a simplified fashion is the key to the technique of sketching.

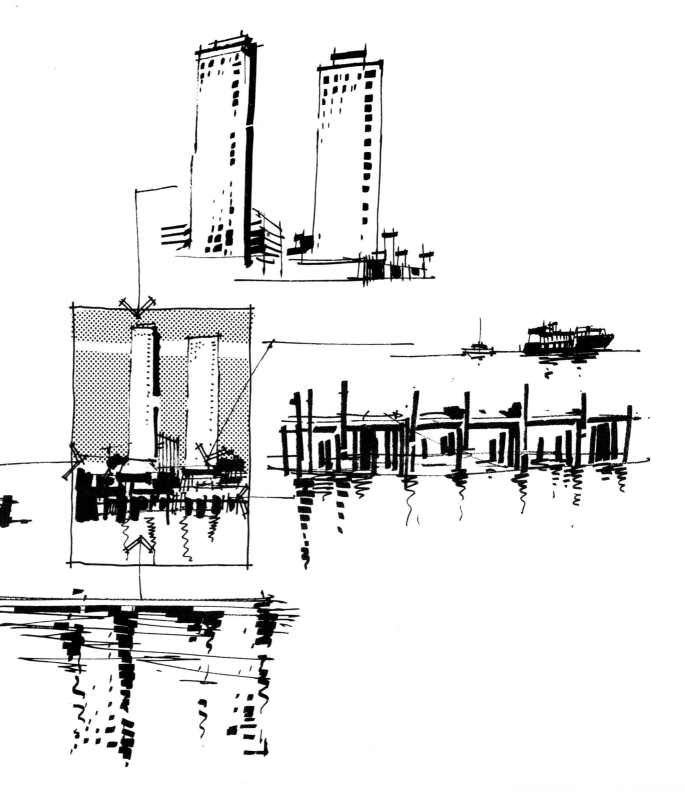

Degree of Abstraction

Sketching is a form of graphic short-hand. The primary objective is to record the image quickly with a variety of lines and tones. Despite its simple, semiabstract appearance, the theme (subject matter) of a sketch must be recognizable. The relative proportion and scale of all major components must be accurately portrayed.

a abstract interpretation

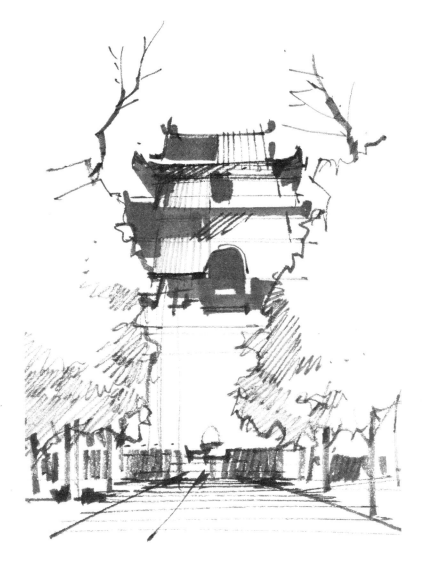

b reality

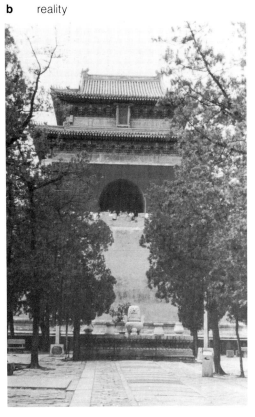

Title: Boats
Original Size: 9 x 13 inches
Medium: Pilot razor point on bristol board
Technique: combination of line and line texture

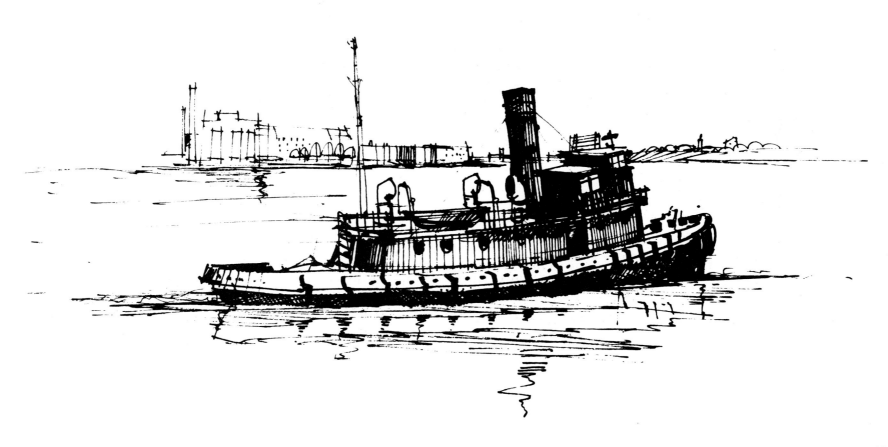

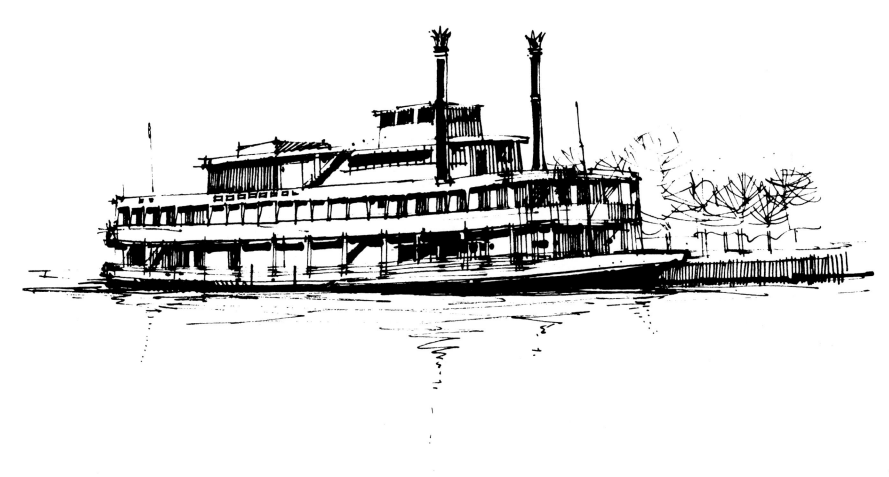

EQUIPMENT

The style and the quality of markers are constantly improving. Henry C. Pitz, in his book *Sketching with the Felt-tip Pen* (1959), referred to the felt-tip pen as "the new tool." At that time it was a new invention and was certainly a novelty to artists. The marker has since evolved into one of the most popular drawing media, replacing pen, pencil, and other color media. It is widely used for a number of good reasons: it is simple to work with; it dries fast and it usually does not smudge; it comes in numerous premixed colors and a variety of tip designs; its nib is often soft and penetrating; and, above all, the marker is convenient.

The marker also has its drawbacks. It is not an inexpensive medium. It also has a relatively short shelf life. The penetrating effect of most markers requires special paper, and bleeding is extremely difficult to predict and control. The convenience of premixed color, on the one hand, eliminates the creative possibilities of color mixing, on the other. Over all, its superficial ease in handling is welcomed by most students, who think of it as a lazy man's tool.

The marker should be looked upon as a unique medium. It is neither pen nor pencil and should not be used as such. It has a unique tip that responds to pressure, surface conditions, and fluid characteristics. It is these features that make markers an excellent sketching tool. Therefore, an *intimate* understanding of their characteristics is vital to successful sketching.

Title: Car
Original Size: 8½ x 11 inches
Medium: pentel (black) on bond
Technique: wash the edge with a wet brush in order to dilute the ink

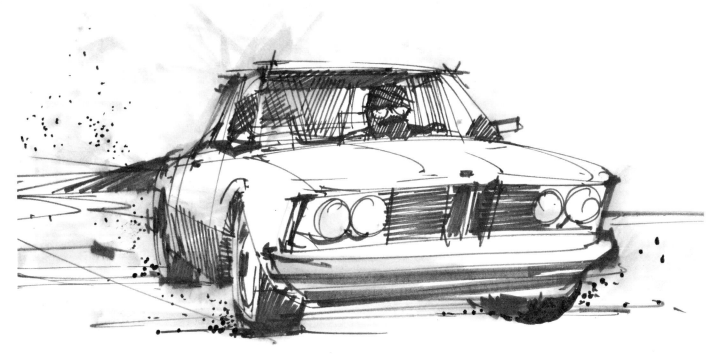

Types of Markers

There are several common types of markers with which one should be familiar:

- Wide-tip (soft-tip) marker, which has a felt tip approximately ¼ inch long and ⅛ inch wide. It is responsive to pressure and twisting and it produces smooth and consistent broad strokes.
- Pointed-nib (bullet-point) marker, which has a semisoft, conical felt tip. It responds to pressure and to various positions and is capable of producing a variety of line widths. It works like a soft pencil.
- Fine-point marker, which has a sharp, hard tip of either felt or nylon. It is an excellent ink-pen substitute when new. The point, however, is subject to pressure and wear.
- Fine-line marker, which comes in a small pen-size container for easy holding and is ideal for drawing details. The new ball-point or hard nylon nib produces broken lines when moved rapidly and tends to scratch the paper surface. This latter type is not recommended for general sketching.

a regular wide-tip

b pointed-nib

c fine-point

ultra-fine point

hard nylon point

chisel-point

ball-point

d types of fine-line mar'

Paper

The character of a sketch relies a great deal upon the surface on which it is drawn. You should pay close attention to the type of paper you use and should understand its characteristics as you get acquainted with your markers. There are many choices, and you should discover your favorites by a process of trial and error. In general, avoid papers that can be penetrated and that bleed easily, unless you desire a special effect. The beginner should try Aquabee felt-tip-marker paper, which has a waxy coating on the reverse side, or Aquabee magic visualizer. Advanced and daring sketchers can try watercolor paper, rice paper, or even white dinner napkins. Your creativity and imagination are your only limits, and appropriateness is a matter of taste.

Some popular varieties of paper are the following:

- Bristol board is smooth, thick-bonded, with a high gloss, and is excellent for fine-line drawing.
- Blueprint paper is soft, absorbent, and loose in fiber; bleeding and penetration is difficult to control.
- Rice paper has a coarse texture, is highly absorbent, and exhibits an unpredictable bleeding pattern. It has an explosive effect when wet. There is a vast range in quality.
- Watercolor paper, which has a coarse, rough surface, will wear out fine-nib markers. It has an excellent surface for tone and mixed media, but is not suited for line drawing.

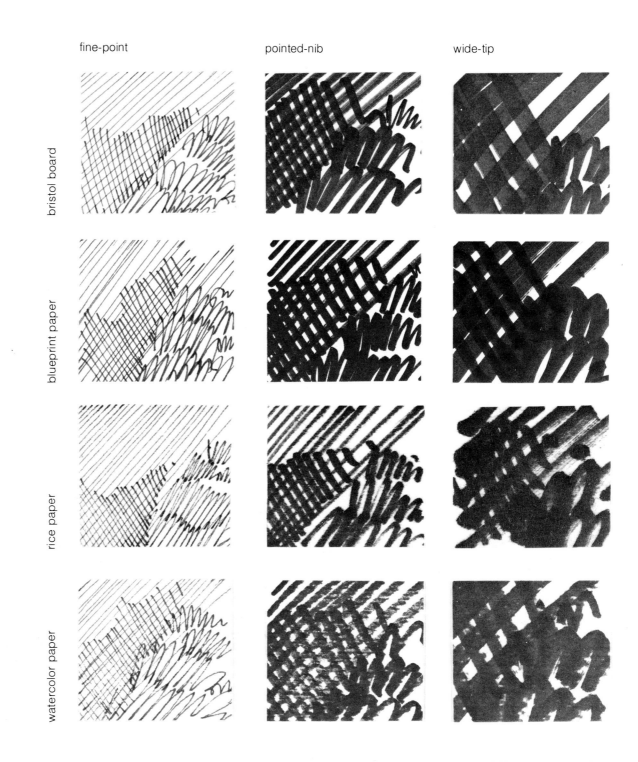

fine-point pointed-nib wide-tip

bristol board

blueprint paper

rice paper

watercolor paper

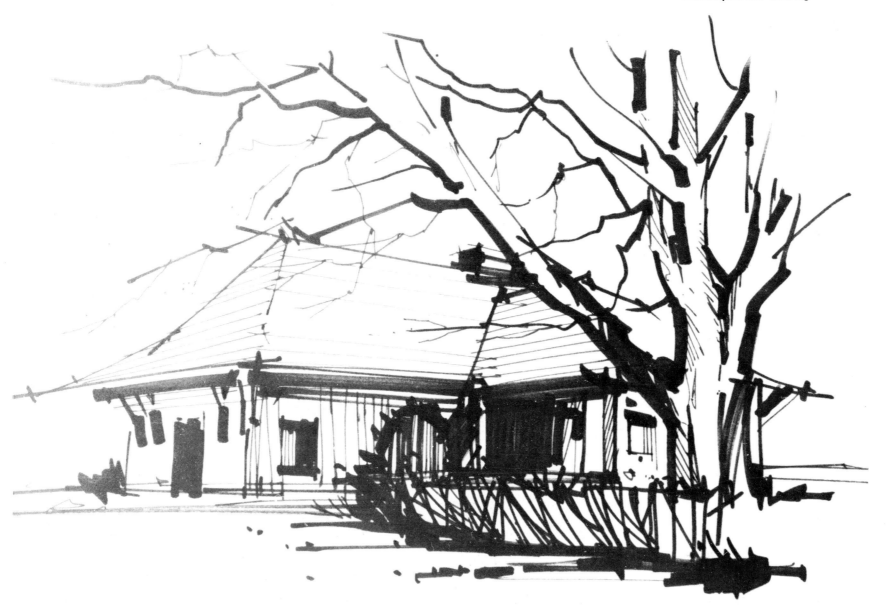

Title: H. H. Richardson's Railroad Station, Easton, Massachusetts
Original Size: 9 x 12 inches
Medium: Eberhard Faber (pointed-nib) on bristol board
Technique: line drawing

Title: same as page 19
Original Size: same
Medium: Eberhard Faber (pointed-nib) on watercolor paper
Technique: line drawing

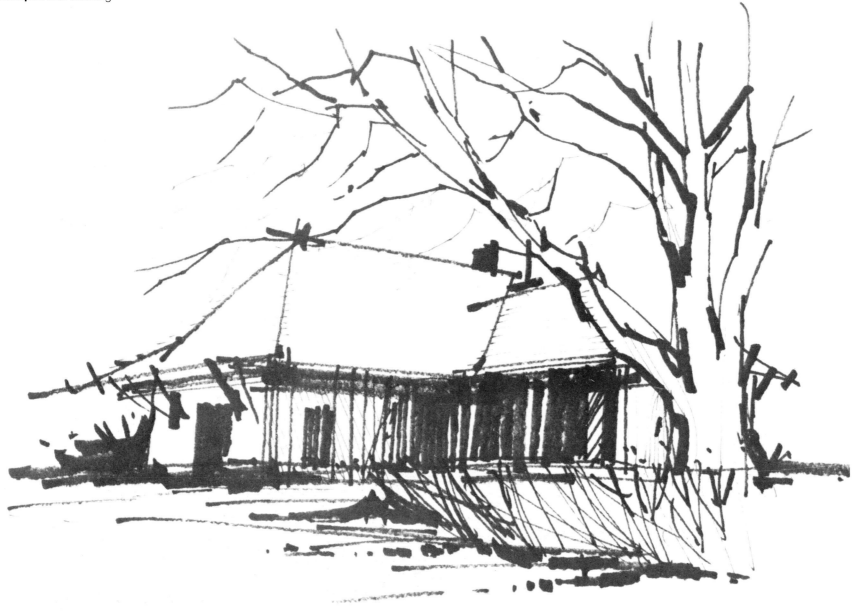

Title: same as page 19
Original Size: same
Medium: Eberhard Faber (pointed-nib) on rice paper
Technique: line drawing

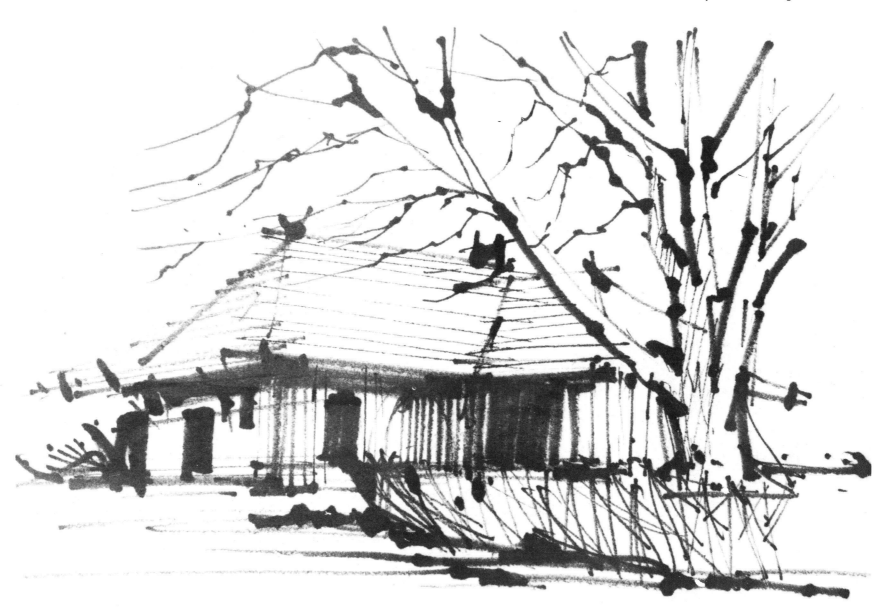

Title: same as page 19
Original Size: same
Medium: Eberhard Faber (pointed-nib) on
Aquabee felt-tip-marker paper
Technique: line drawing

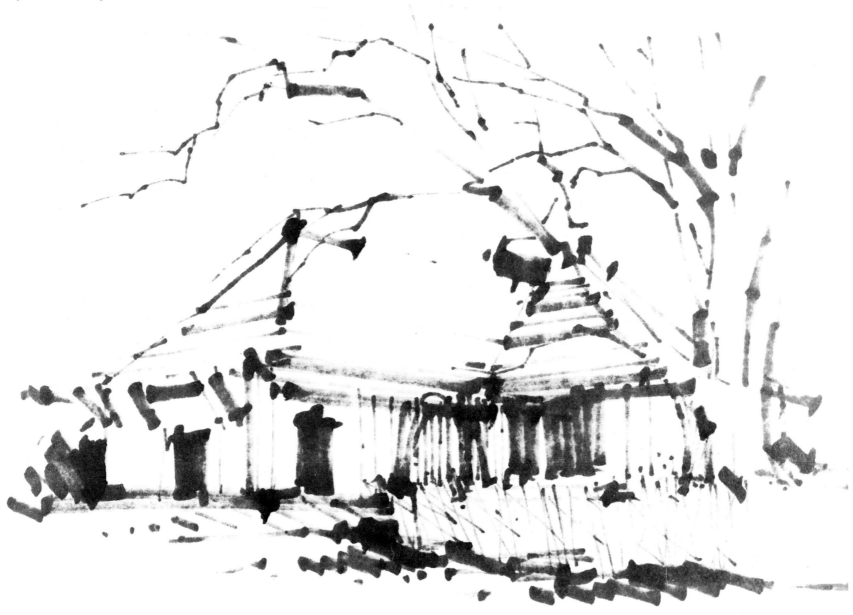

LINE

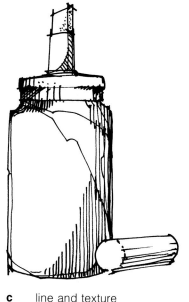

a line profile

b texture

c line and texture

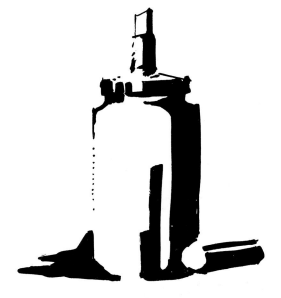

d tone (high contrast)

e tone (with grays)

A line is a straight or curved connection between two points. It defines a spatial edge that separates a mass from a space. It delineates detail and renders the effects of a light source. It brings out the three-dimensional quality of an object. Line can be expressed in many ways, according to width, length, density, orientation, and appearance. Marker line produces texture and tone easily due to nib variations. Line quality is an evaluation of line function, line type, line movement, and line expression. A line drawn with a marker is inherently and characteristically different from a line drawn with a pencil. A marker line is controlled by the size and condition of the nib and the type and quantity of the ink storage. The art of working with markers is also unique because of the nib construction and size variation. For example, ink flow in a new marker is quite consistent; in order to lighten the tone, you must switch to a lighter-color or a semidry marker. Variation of hand pressure is not used to control tone, but rather to control line width and movement.

Types
of Lines

There are many types of lines:
- lines drawn with even pressure, pulled from left to right (fine point)
- lines drawn in a series of short pauses at random intervals, with the marker remaining on the paper (fine point)
- lines drawn in a series of short pauses at random intervals, with the marker removed from the paper (fine point)
- short strokes
- lines drawn with a pointed-nib marker, varying the pressure on the point
- lines drawn with a pointed-nib marker, twisting and varying the pressure
- casual, short nondirectional strokes (fine point)
- casual short strokes drawn with a pointed-nib marker
- lines drawn with a semidry pointed-nib marker
- wide-tip-marker strokes
- series of short, casual arcs
- series of small, flat loops

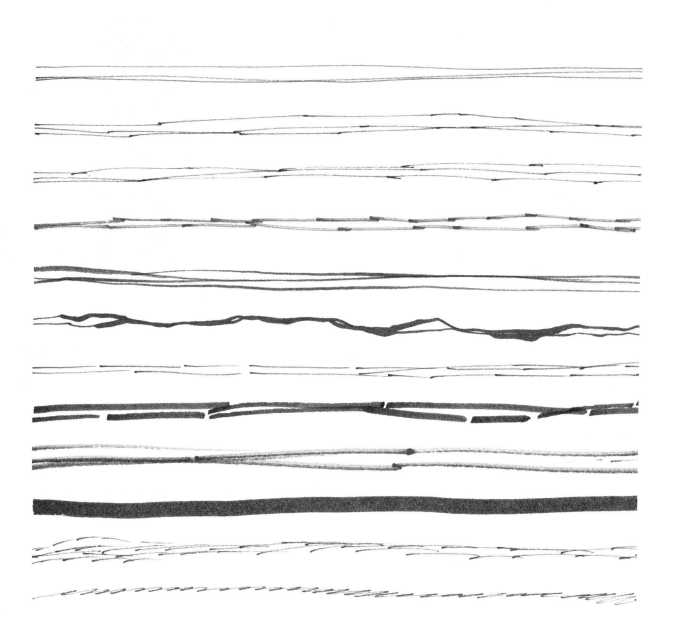

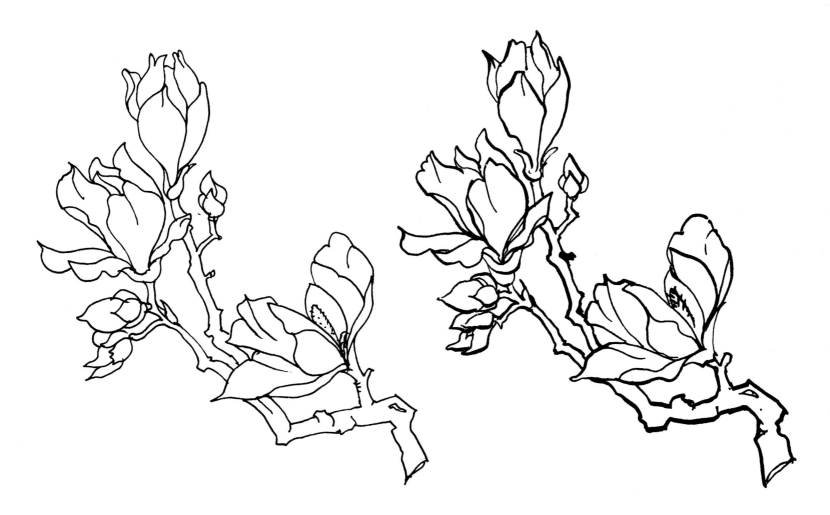

a line drawn without varying pressure on the point **b** line drawn by varying pressure on the point

Title: Egyptian Children
Original Size: 8½ x 11 inches
Medium: Eberhard Faber (pointed-nib) on bond
Technique: line

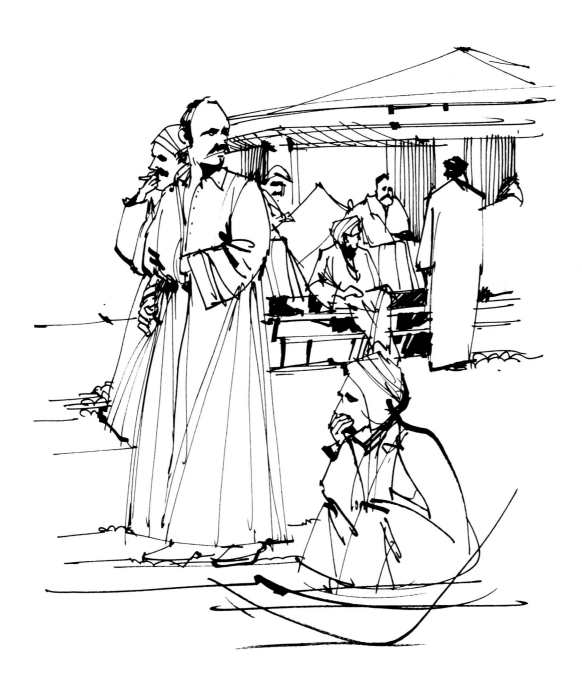

Title: Egyptian Men
Original Size: 8½ x 11 inches
Medium: Eberhard Faber (pointed-nib) on bond
Technique: line

Wide-tip-marker Lines

The wide-tip-marker is a unique drawing tool because of its broad ½- to ¼-inch felt nib. As a tone medium, it is ideal for filling in areas between lines. As a line medium, the broad strokes can quickly define an area and therefore simplify the sketch. Semitransparent juxtapositioning of broad strokes injects new life and character into a drawing by giving it contrast and motion. The application of the wide-tip marker to sketching is similar to the use of pastels and oil-painting brushes: all have a premeasured applicator. It is this characteristic that makes markers unique. Rather than simply using them for filling in areas, a task that can be done with many other color media, this characteristic should be creatively exploited.

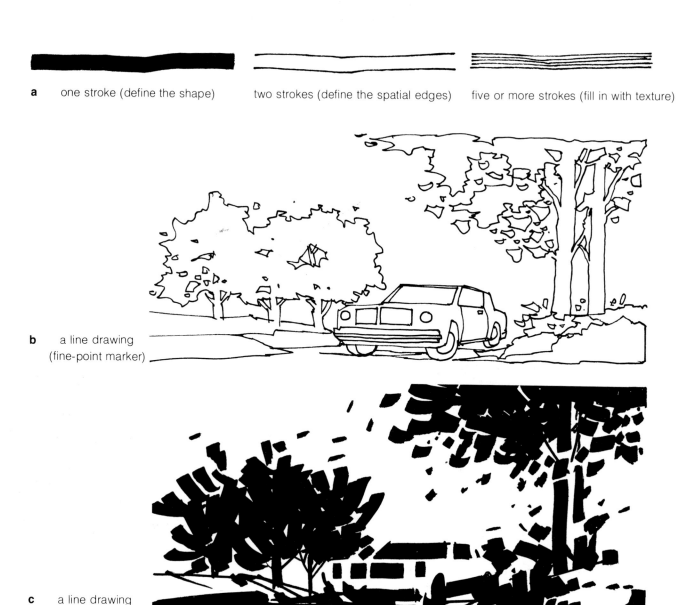

a one stroke (define the shape)

two strokes (define the spatial edges)

five or more strokes (fill in with texture)

b a line drawing (fine-point marker)

c a line drawing (wide-tip marker)

Title: Mosque in Cairo, Egypt
Original Size: 9 x 12 inches
Medium: Pilot razor point on bristol board
Technique: line texture

Title: Palace at Heliopolis, Egypt
Original Size: 9 x 12 inches
Medium: Pilot razor point on bristol board
Technique: line texture

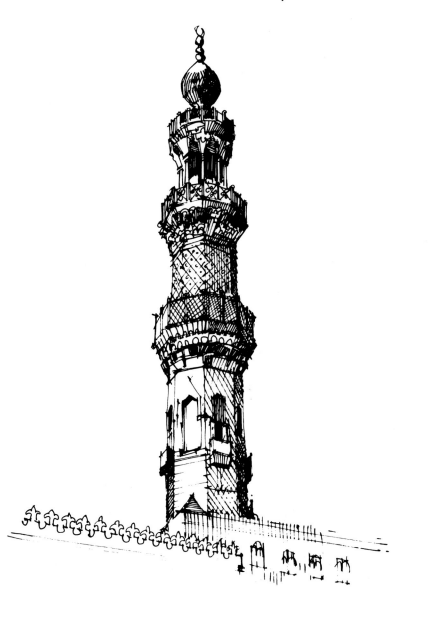

Title: ERB Student Union, University of
Oregon
Original Size: 11 x 14 inches
Medium: Pilot razor point on Aquabee
felt-tip-marker paper
Technique: line

Title: Street Scene
Original Size: 11 x 14 inches
Medium: Pilot fine-line and watercolor
marker on watercolor paper
Technique: line drawing and wash

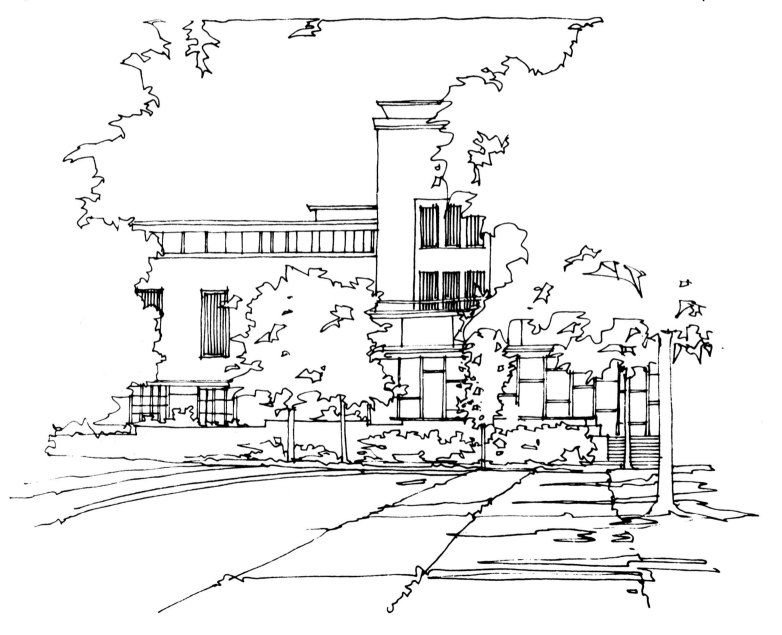

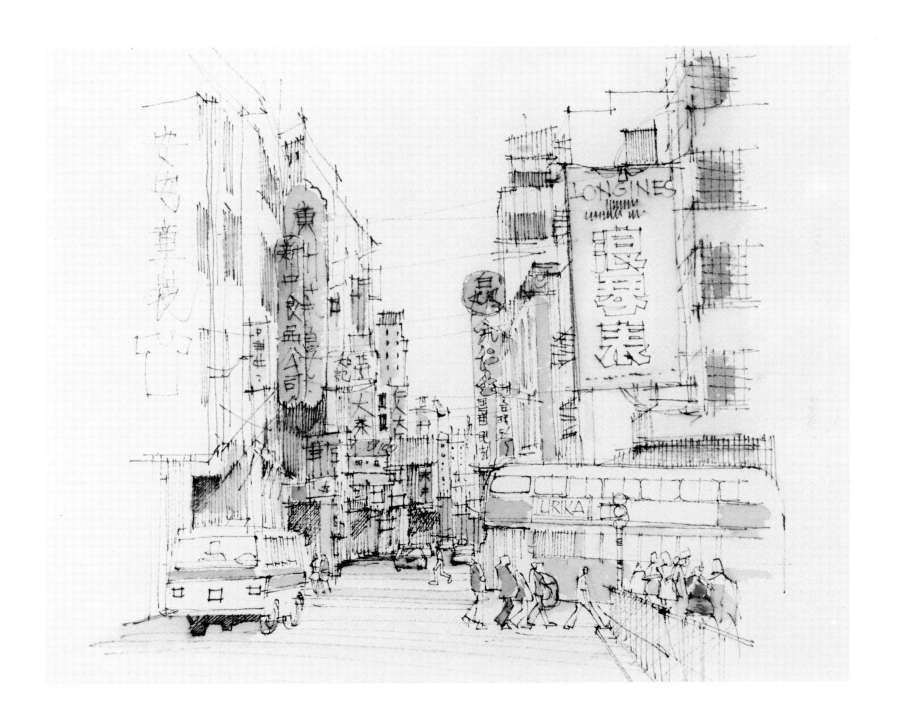

TEXTURE

Texture consists of semiabstract graphic symbols that signify the surface or material of the drawn object. The tonal effect of texture also helps to enhance the sensation of depth in two-dimensional representation.

There are two basic types of texture: lines and dots (screens). The meaning and effect of these textures depend upon the interpretation of size, overall density, line orientation, spacing, and overall tonal effect.

Line texture can be divided into parallel and nonparallel (better known as "squiggles" or "scribbles") patterns. Parallel lines (including crosshatching) are often used to express vertical or horizontal planes that have a smooth surface. The spacing between lines and the line width should be kept consistent throughout a rendered plane. It is an abstract expression, and the artist should not be too concerned with the literal meaning of the material. Nonparallel lines are a bundle of loose threads. The line width and the spacing are often varied in order to achieve a desired density and tonal effect. These lines are ideal symbols to depict vegetation and for undulating surfaces.

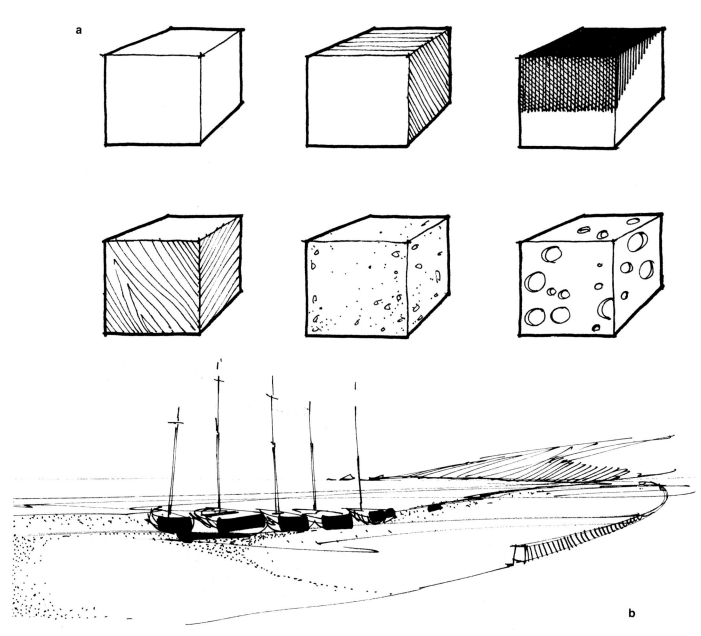

a

b

Types of Texture

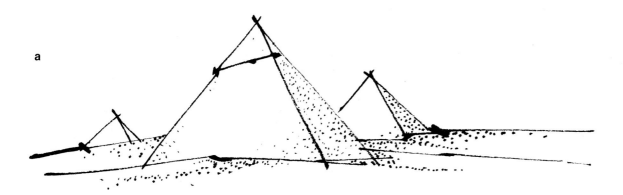

a

dots

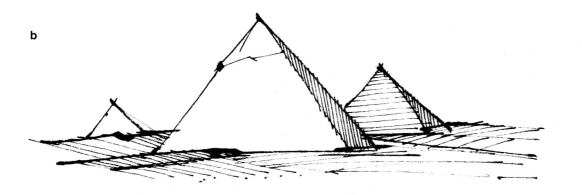

b

lines (parallel)

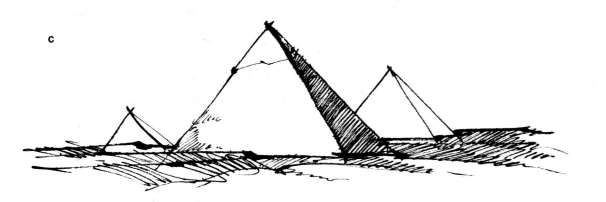

c

lines (scribbles)

b layout sketch done with a pentel

a texture (scribbles) drawn with a fine-point marker

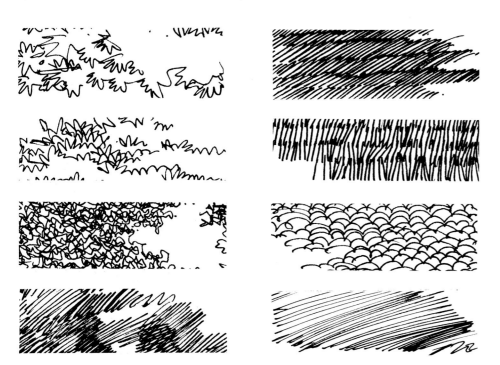

c layout sketch done with a pentel

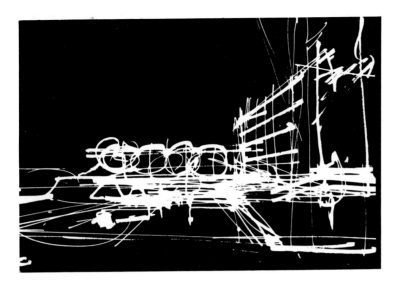

a layout sketch done with a pentel

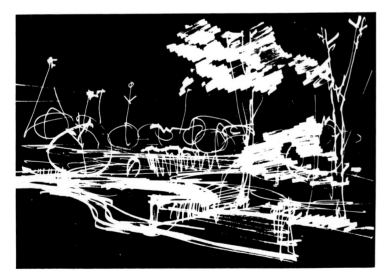

b layout sketch done with a pentel

c texture (scribbles) drawn with a point-nib marker

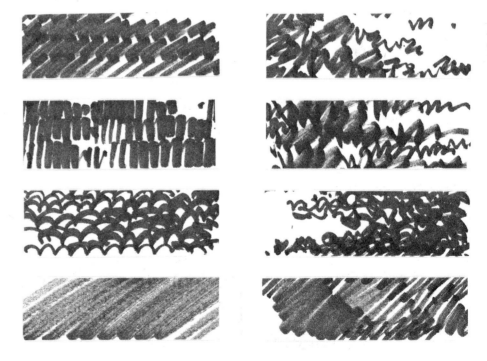

Parallel Line Texture and Direction

a photograph

b profile line

c line texture (cross-hatching) used to create tone and separate depth; lines parallel with the edges of paper

d line texture used to create tone and separate depth; lines parallel with different surfaces

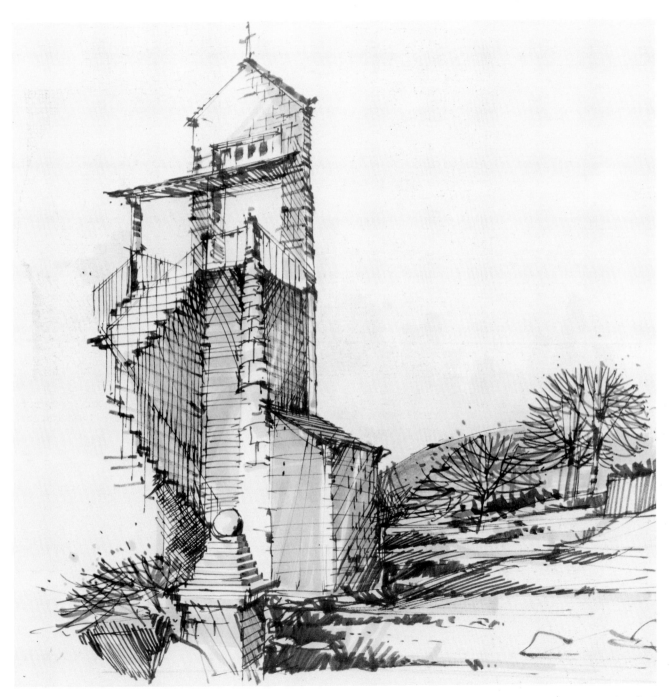

Title: Bell Tower at Altos de Chavon, The Dominican Republic
Original Size: 8½ x 11 inches
Medium: color marker on bristol board
Technique: textures were made with color marker with ultra-fine nib

Title: sketchings of museum figures
Original Size: 8½ x 11 inches
Medium: semidried pentel on bond paper
Technique: line drawing

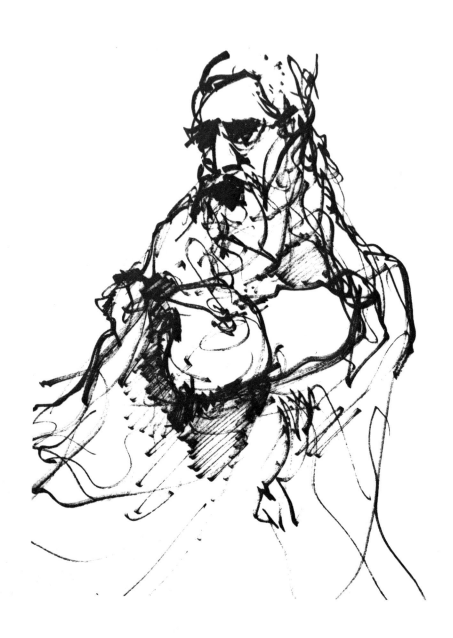

TONE

Tonal value can be achieved either through textural density or varying line widths. It is used in most sketches to increase the feeling of depth and to bring out the three-dimensional quality of the various components. Generally speaking, the sun side should be brighter (less dense) than the shaded side. The shadow pattern is often rendered in black, dark gray, or dense, thick lines. Tonal contrast is important in reading depth, so a substantial white area should be preplanned and reserved in order to achieve this special effect.

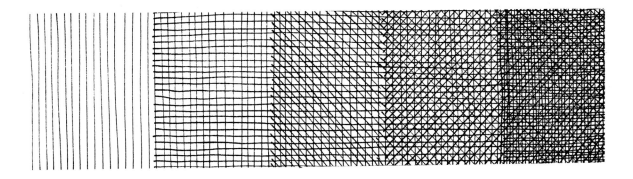

Line Texture
and Tone

a photograph of a street

b line interpretation

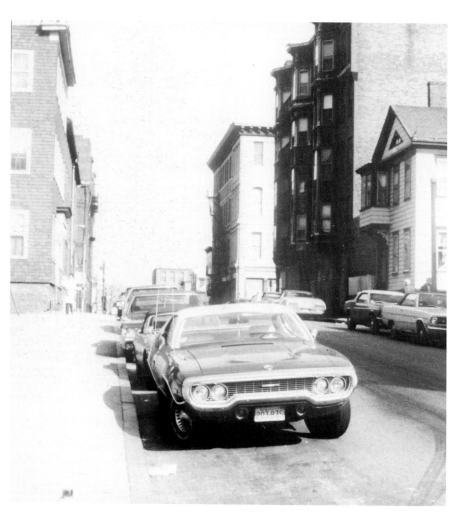

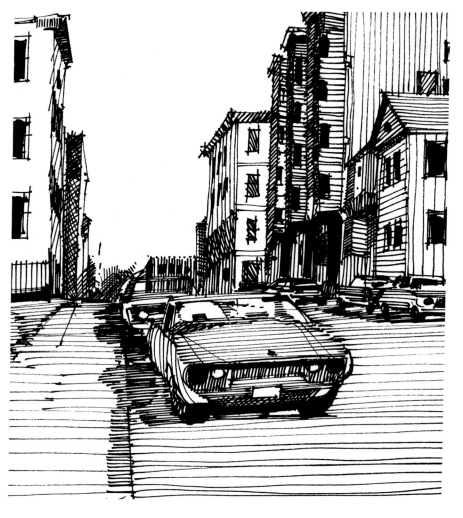

a tone interpretation I (high contrast)

b tone interpretation II (gray tones)

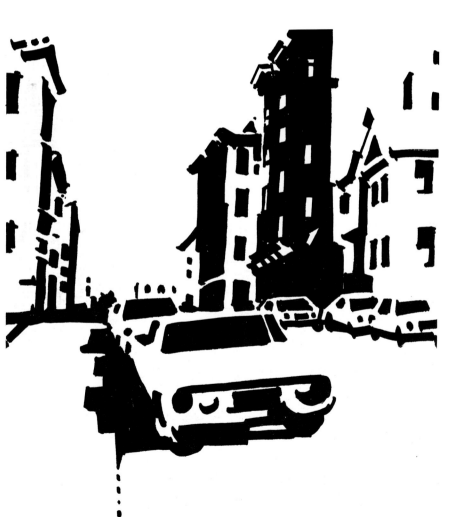

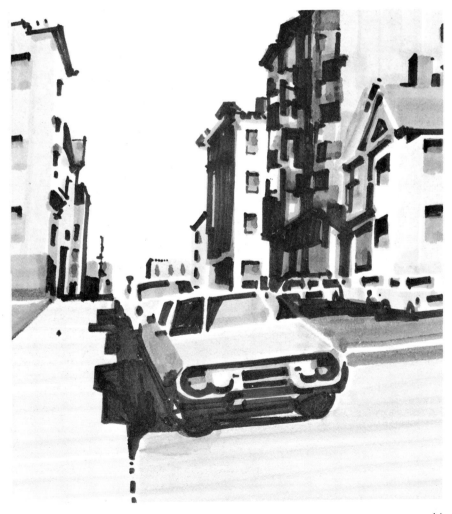

Gray Markers

A gray marker is ideal for the creation of tone. However, the result is often unpredictable and the effects are inconsistent. The warm-gray and cool-gray ranges are excellent tone media. There is not much perceivable difference between two consecutive grays: for better and sharper differentiation, try skipping at least one shade. Warm-gray is better for blending with other colors. Cool-gray has a metallic appearance and tends to stand out.

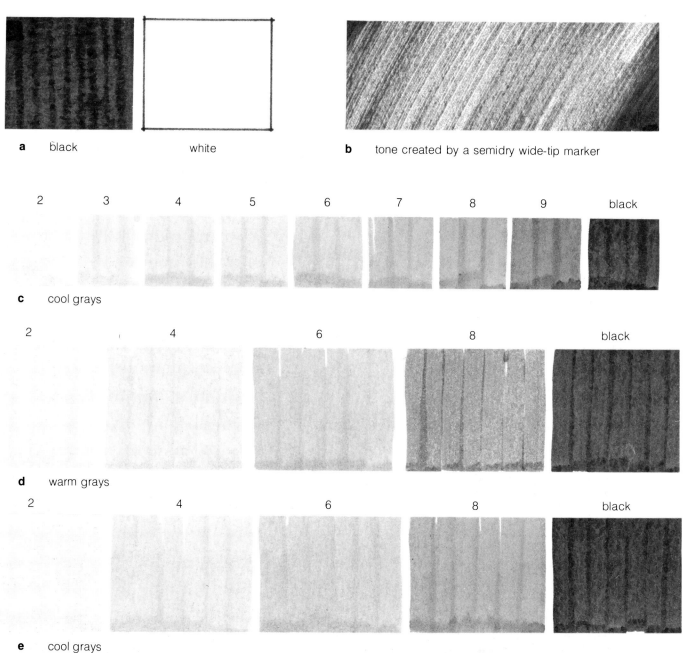

a black white

b tone created by a semidry wide-tip marker

2 3 4 5 6 7 8 9 black

c cool grays

2 4 6 8 black

d warm grays

2 4 6 8 black

e cool grays

42

Title: Building in Boston
Original Size: 24 x 30 inches
Medium: black marker on brown butcher paper
Technique: copy from slide; black marker used to produce the high-contrast look; use of line to define spatial edges is minimal

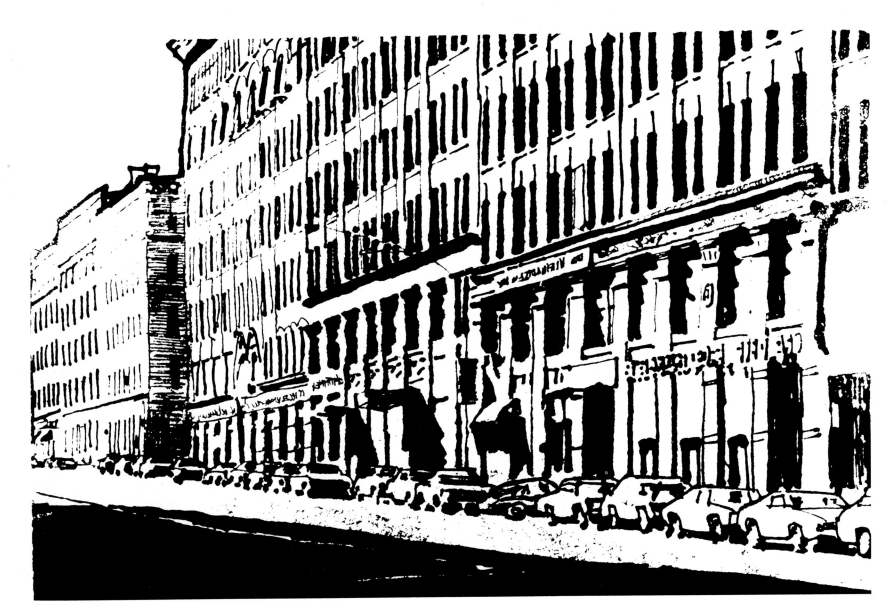

Title: Egyptian Donkey Cart
Original Size: 9 x 12 inches
Medium: black and gray markers on bristol board
Technique: line drawing and broad marker strokes

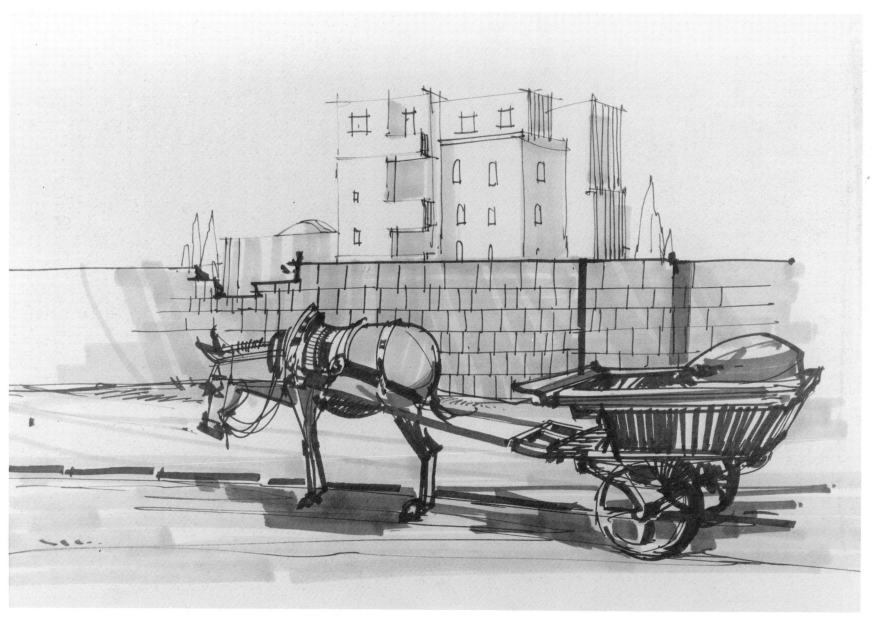

Title: Quechee Lake, Vermont
Original Size: 9 x 12 inches
Medium: gray and black markers on bristol board
Technique: line drawing filled in with gray markers

Title: House in Alexandria, Egypt
Original Size: 8½ x 11 inches
Medium: Pilot razor point on bristol board, shading in gray marker
Technique: line and tone drawing

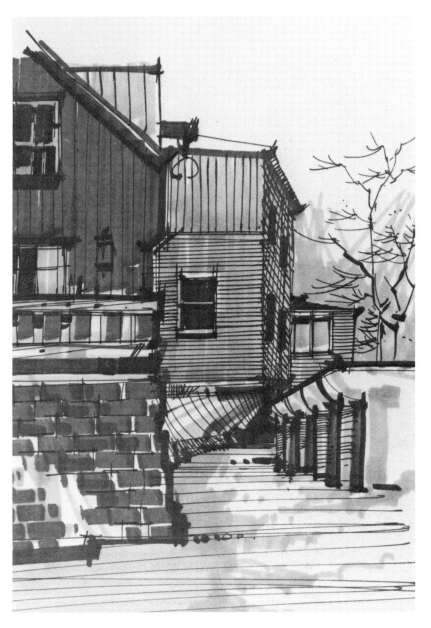

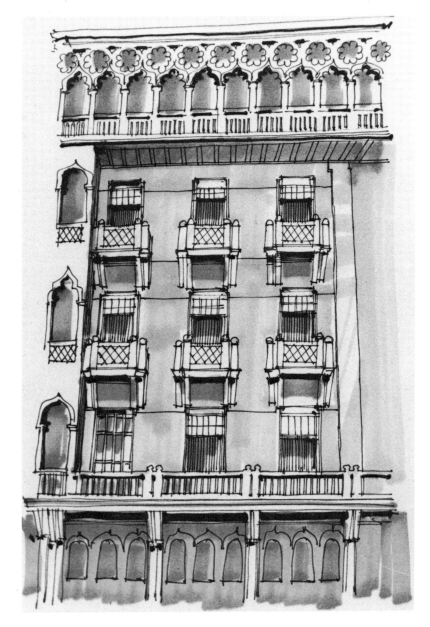

45

Title: building facade (detail)
Original Size: 8½ x 11 inches
Medium: color markers on bristol board
Technique: use lighter colors to cover large areas; details picked up by thinner strokes; shadows done with gray and #6 applied at the very last minute

Title: Austin Hall, Harvard University
Original Size: 8½ x 11 inches
Medium: black and gray markers on felt-tip-marker paper
Technique: outlining done with Pilot fine-point

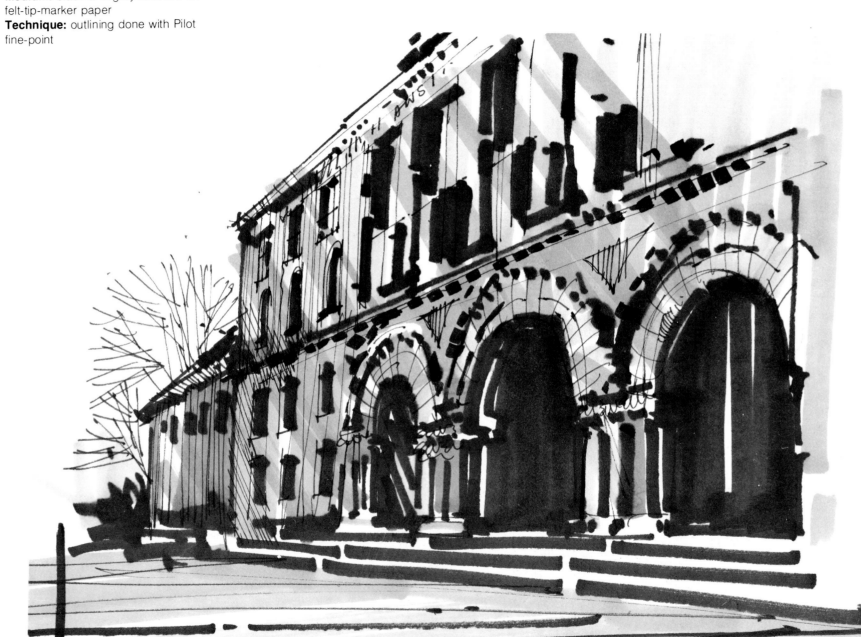

Selection of Color Markers

Color choices of markers are ever increasing. It is indeed difficult to start a useful collection because of the many variations of styles and colors and because of the cost factor. You should choose colors according to basic need rather than on impulse. Look for colors that blend well with each other instead of setting up a kaleidoscopic selection. Limit your selection to not more than fifteen or twenty markers. You can always add to your collection as you progress.

The first criterion for selection is the function of the marker. In terms of color there are three separate but closely related functions:

• Prime colors (base colors) are those that will be used to cover a large area, such as an area of vegetation, architecture, water, or sky. They should be soft and warm and should be able to blend well with all the adjacent colors.

• Supporting colors enhance prime colors. They are used for textural buildup, shading, and edge sharpening.

• Accent colors are for highlighting They are usually bright, attractive and contradictory. They are often used for cars, signs, clothing, and the like. The location of these colors should be carefully selected: don't overdo them. Since the area of coverage is relatively small, pointed-nib markers are more suitable than wide-tip markers.

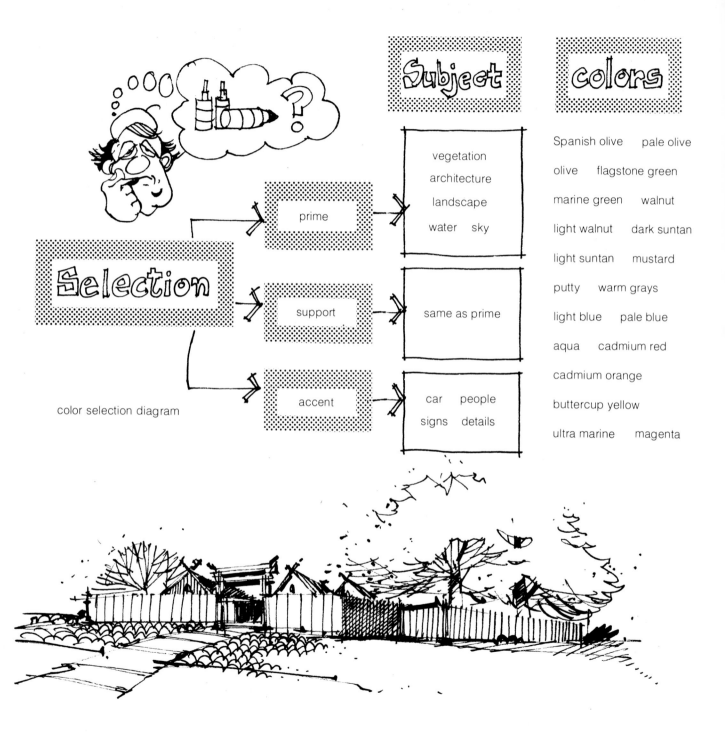

color selection diagram

Subject

prime	vegetation architecture landscape water sky
support	same as prime
accent	car people signs details

colors

Spanish olive pale olive

olive flagstone green

marine green walnut

light walnut dark suntan

light suntan mustard

putty warm grays

light blue pale blue

aqua cadmium red

cadmium orange

buttercup yellow

ultra marine magenta

Use of Color Markers

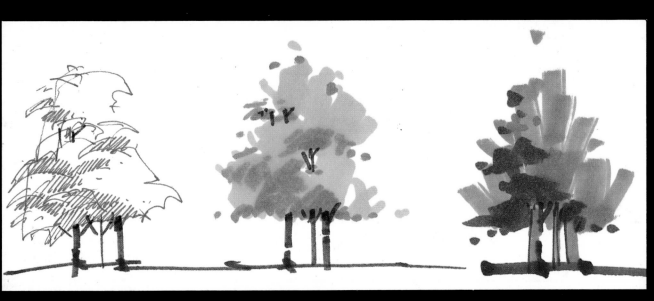

a line drawing (fine-line marker) **b** tone drawing (pointed-nib marker) **c** tone drawing (wide-tip marker)

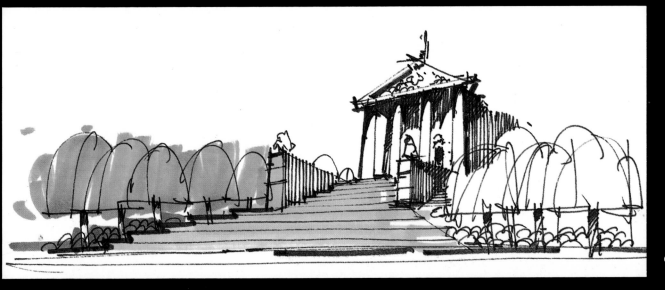

d comparison between tone and line drawing

DEMONSTRA-TION I

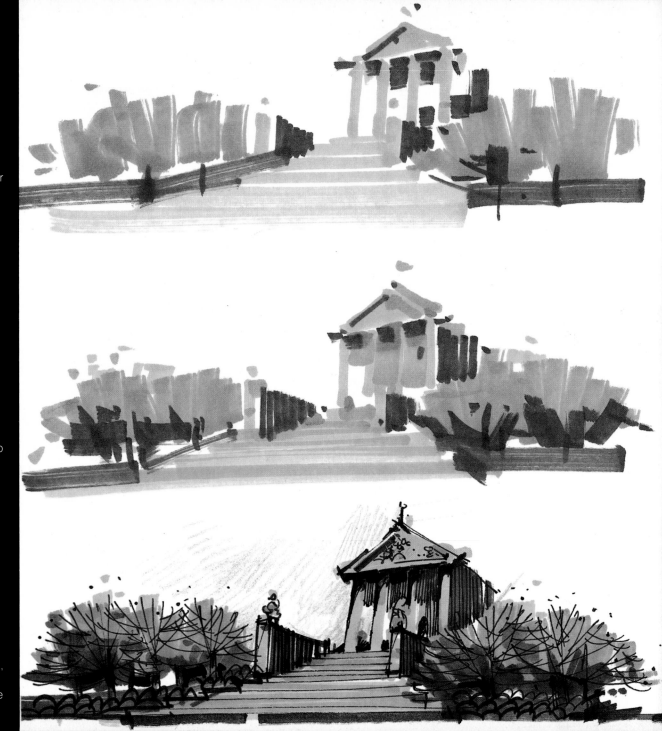

a use Spanish olive as base color for tree, mustard for building

b add flagstone green under the canopy of trees to give depth, add grays to building

c highlight corners with bright colors, use black to·define spatial edges of building and the structure of trees, shade sky with a light blue pencil

Michigan
Original Size: 8½ x 11 inches
Medium: color marker on bristol board
Technique: broad marker strokes over line drawings

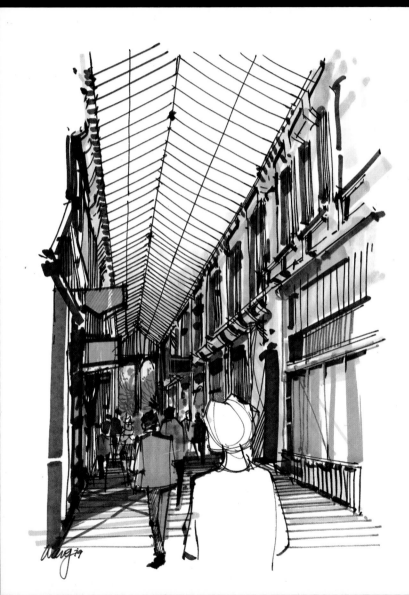

Title: Temple, Japan
Original Size: 8½ x 11 inches
Medium: color marker on bristol board
Technique: Eberhard Faber chisel-point marker used for outline

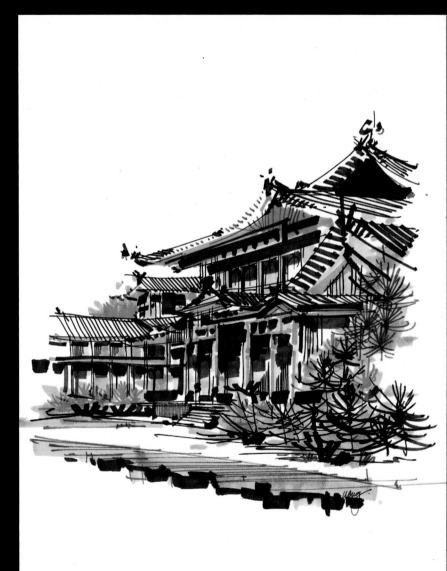

Title: Kowloon, Hong Kong
Original Size: 8½ x 11 inches
Medium: Pilot fine-line and watercolor marker on watercolor paper
Technique: line drawing and wash

Original Size: 8½ x 11 inches
Medium: Pilot razor point and watercolor
Technique: line drawing and wash

Title: Central District, Victoria, Hong Kong
Original Size: 9 x 14 inches
Medium: Pilot fine-line marker and
watercolor wash on watercolor paper
Technique: line drawing and wash

Title: Central District, Victoria, Hong Kong
Original Size: 11 x 14 inches
Medium: color markers on Aquabee
felt-tip-marker paper
Technique: line drawing; some spatial
edges defined by broad marker strokes

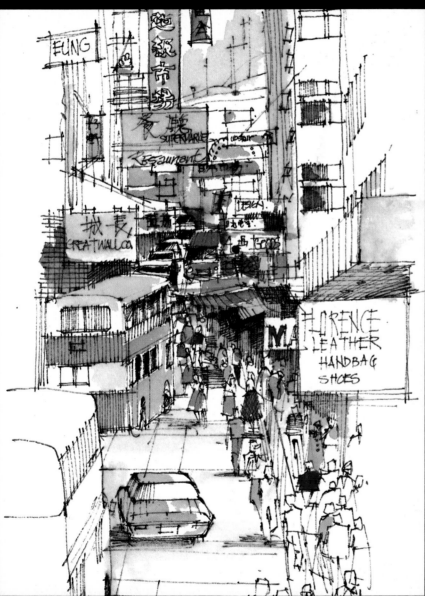

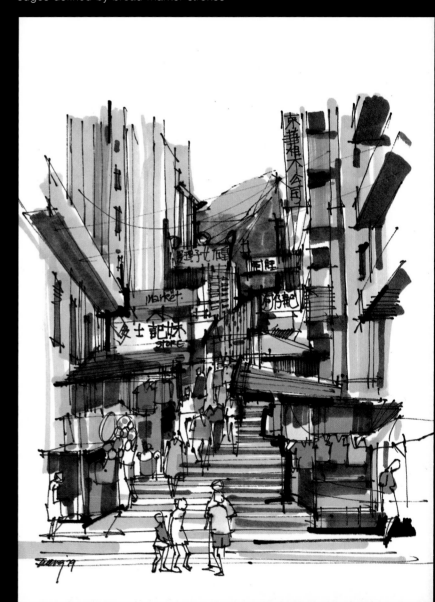

Title: studio demonstration
Original Size: 14 x 17 inches
Medium: color marker on rice paper
Technique: highlights sharpened with
Eberhard Faber pointed-nib

Title: studio demonstration
Original Size: 8½ x 11 inches
Medium: color marker on watercolor paper
Technique: very broad strokes

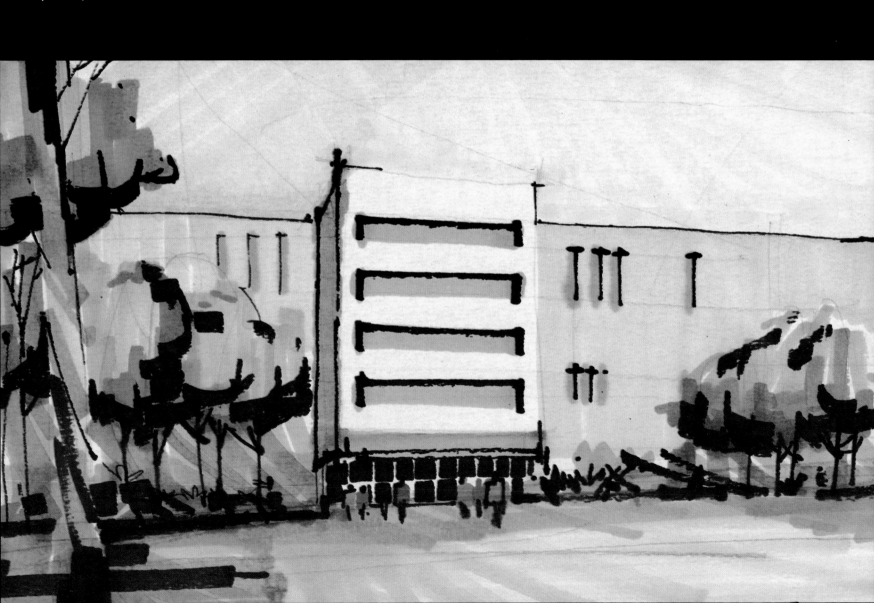

no tricks !! just practice

a diagonal strokes over vertical strokes create uneven shadow pattern

b parallel strokes (roof and wall)

d spatial edges outlined and sharpened by fine-line marker, wall detail also shown

c gray marker for base color, spatial edges outlined by fine-line marker

e roof and wall details revealed, darker gray used to cast shadow

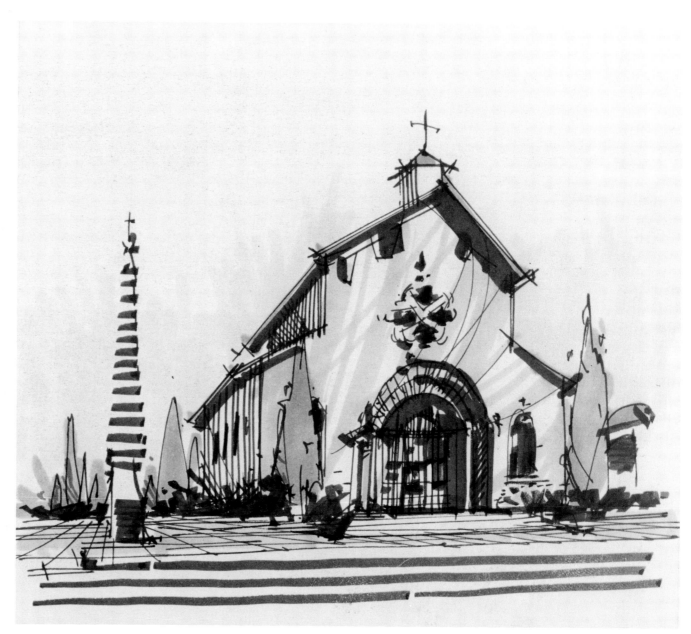

Title: Church in Altos de Chavon, The Dominican Republic
Original Size: 8½ x 11 inches
Medium: color markers on bristol board
Technique: use broad color strokes to define masses; thin black outlines done at the last minute

58

Title: studio demonstration
Original Size: 11 x 17 inches
Medium: color marker on watercolor
paper
Technique: sketching

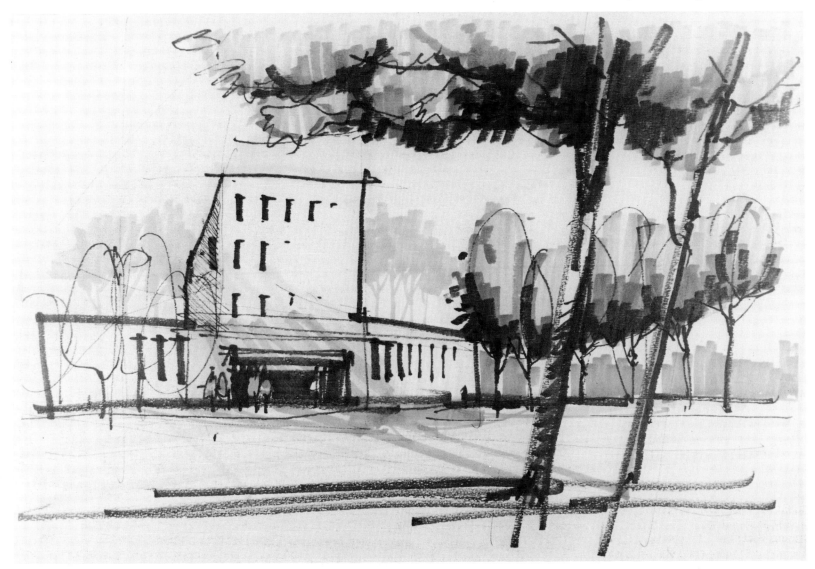

SKETCHING

Sketching is really a reflex action, the result of perceptual experience. There are two types of sketching: you either sketch what you see or what you remember. In the course of transforming real images into drawn symbols, you go through three stages: identification, simplification, and expression. (Keep in mind that this is an oversimplified analysis of the sketching process. What really goes on in your mind and how you graphically express an image are complex and difficult to understand.) A gradual learning process is involved: you must learn how to draw before you can sketch. It is like learning how to stand and walk before you can run. Being able to draw precisely, carefully, and realistically is a necessary discipline before attempting the more difficult task of graphic shorthand. Unfortunately, there is no shortcut: you must be patient and willing to work hard.

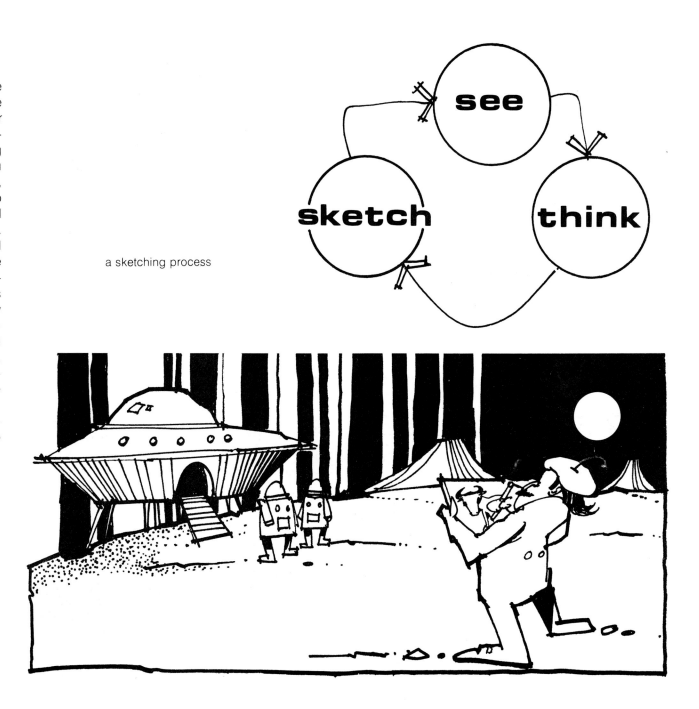

a sketching process

60

WHAT ?
HOW ?

Seeing

Since sketching records visual experience, the art of seeing and the things we see are indeed the crucial factors in sketching.

Most of our visual experiences have to do with a perceived message. People endow the objects they see with a certain meaning, which is factual and utilitarian. For example, observers may identify a door as a door that leads to a restaurant; a house, as a courthouse. Seeing in sketching should precede such facts. First of all, you should be aware of the juxtapositioning of objects, the changing of colors, the variation in contour and light quality, and the liveliness of lines and edges. Before interpreting the meaning of the things you see, you should first appreciate the proportion, the scale, the texture, and the composition of the entire image. This is called aesthetic seeing or formal perception.

The Art of Seeing

Kevin Lynch, in his book *Image of the City,* described edges, landmarks, nodes, and paths as the prime visual attractions of the city. Seeing in sketching is quite similar. The three major categories in formal perception are:

- Skyline—look for the mass, landmarks, nodes, and figure/ground relationship.
- Differentiation of light/shade contrast—identify the light source, as it helps to pictorialize the shape of the masses.
- Lines, paths, and edges—these help to identify perspective and locate reference planes and vanishing points.

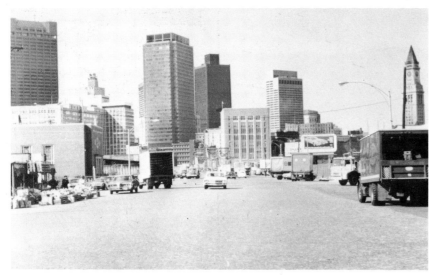

a photograph of a city

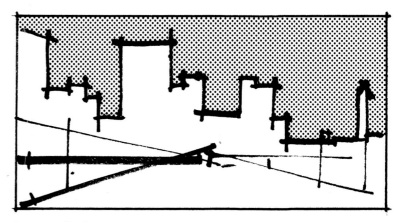

b profile, figure/ground relationship

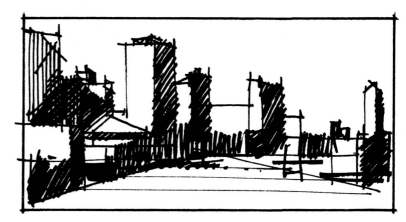

c light/shade contrast, shape identification

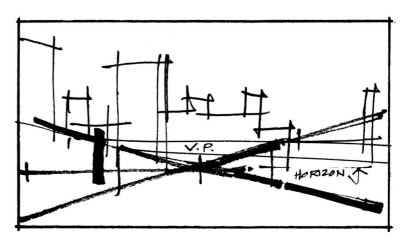

d line, edge, and perspective

The Seeing Process

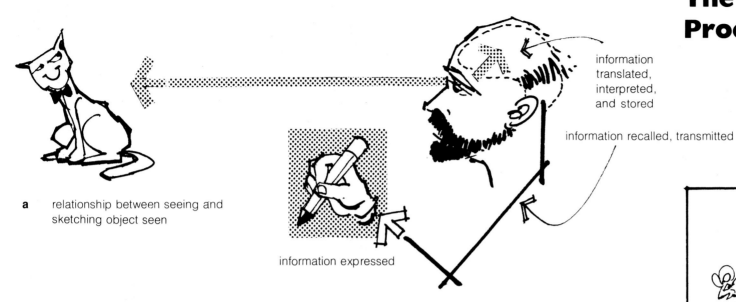

a relationship between seeing and sketching object seen

information translated, interpreted, and stored

information recalled, transmitted

information expressed

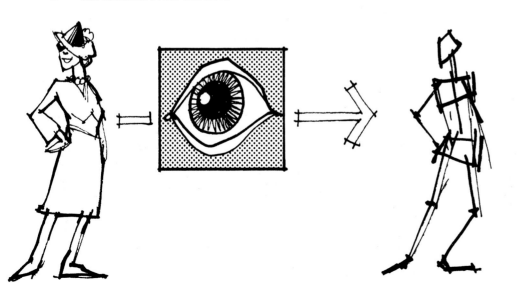

b identification of the structure

c imagination

d literal

e formal

Seeing Methods

Here are several suggestions for aesthetic observation:

- Differentiate the figure/ground relationship and understand the proportion between mass and space.
- Identify the prominent mass and its coverage inside the picture frame.
- Identify the perspective type and locate the horizon line, projection rays, and reference planes.
- Classify the visual field into foreground, middleground, and background.
- Identify the light source and sketch out the tonal contrast of the major planes.
- Identify the shape of masses by following the formative lines (horizontal, vertical, and diagonal).

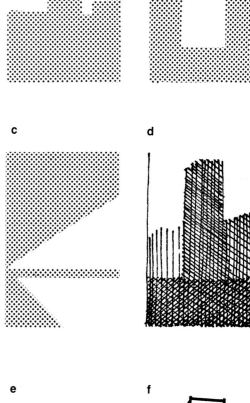

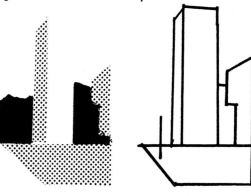

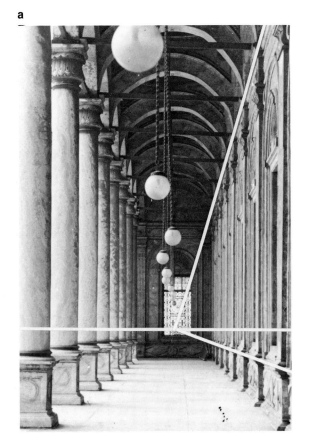

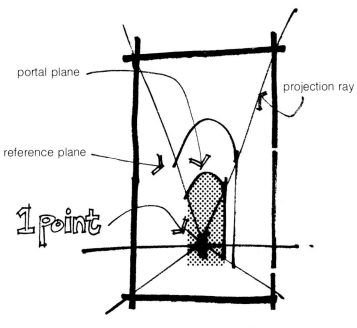

portal plane

projection ray

reference plane

1 point

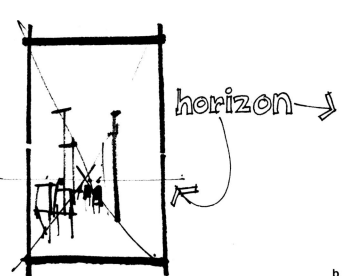

horizon →

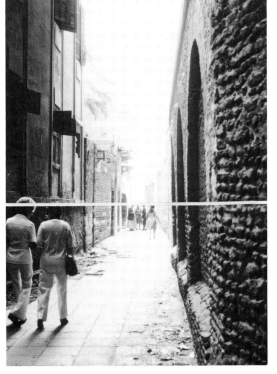

b

One-point Perspective

One of the most important aspects of seeing is to understand the perspective type and structure of the scene. They are the foundation of all measurement, and they determine the proportion and scale of the sketch. Correct perspective is the skeleton of the good sketch. Perspective does not yield a duplicate of the perceived image, but one that comes closest to, or best explains our perceptual experience.

Normally, when we face an object (e.g., Figure a), our line of vision is perpendicular to the frontal or portal plane. In Figure b the frontal plane is a hypothetical plane, and the portal plane is the rear wall and stained-glass window. The reference planes (floor, wall, columns, etc.) and projection lines are parallel to the center of vision. Due to the nature of one-point perspective, these lines tend to look as if they are converging at a distant point located on the horizon (eye level).

Two-point Perspective

Two-point perspectives differ from one-point perspectives in the disappearance of the frontal plane. The viewer has a better vantage point and can see more of and understand better the structure of the image. However, due to the setup of the perspective and the fact that the rate of scale change and size diminishing is greater, the drawing has a greater potential of distortion.

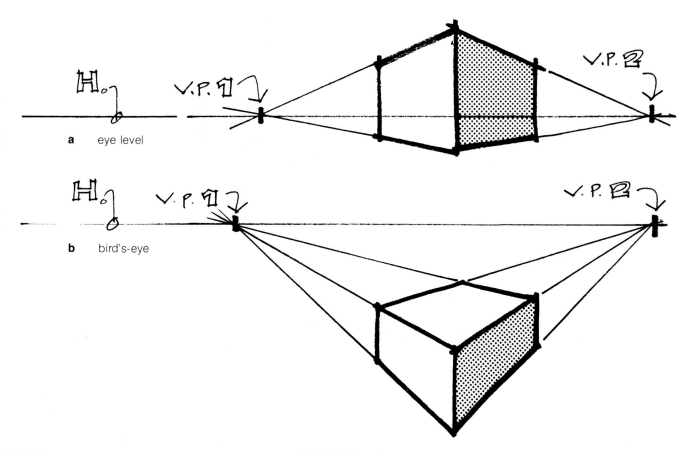

a eye level

b bird's-eye

c

Three-point Perspective

a

to pt. 2

to pt. 3

1 point Perspestive

b

Three-point perspective is a combination of one-point and two-point perspectives. It is a spinoff of a one-point perspective because of the horizontal extension of the frontal plane. The drawing will be extremely distorted unless the frontal plane is bent. This creates a curved picture plane (frontal plane), which functions as a fisheye or wide-angle lens. The purpose is to widen and broaden the coverage, with the intention of enhancing our normal perceptual experience and minimizing distortion.

Natural Scenery

When drawing natural scenery, the frontal plane is often nonexistent, because identifiable reference planes established by built elements are not present. Under such circumstances, one should not rely on the reference planes to establish the benchmark for measurement and scale. The best way to sketch in this situation is to outline the edges of the three major visual fields (i.e., those between foreground, middleground, and background). These edges should be bold and heavy, emphasizing only the major profile and outline of the mass and never the detailed serration of individual elements.

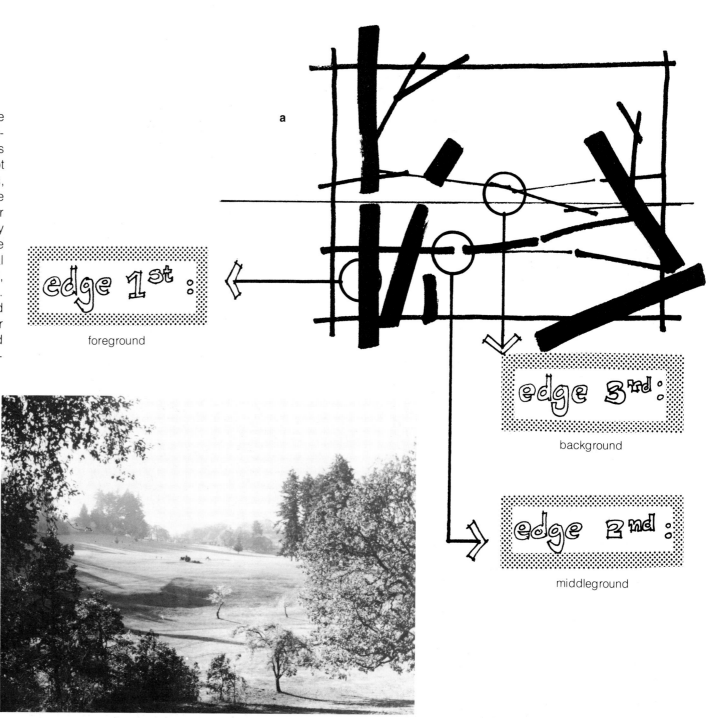

a

edge 1st :

foreground

edge 3rd :

background

edge 2nd :

middleground

b

Special Perspective

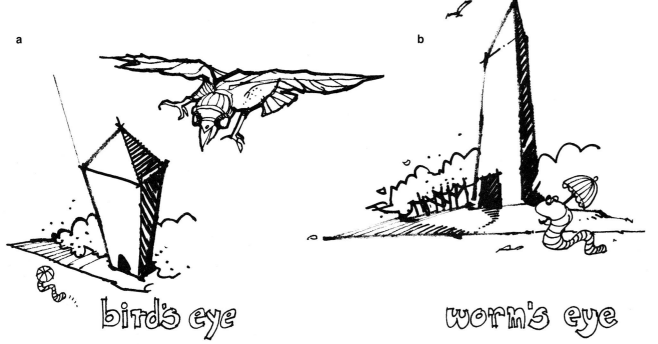

a

b

bird's eye

worm's eye

For special effects in sketching bird's-eye views are among the most frequently used perspectives. The behavior of the horizontal parallel lines is the same as in ordinary perspectives. However, the vertical parallel lines can be drawn either parallel or converging to a point above or below the horizon line. This shift of parallelism exaggerates the scale and extends the sense of height. This technique is often used to sketch tall objects such as highrises or monuments.

Title: studio demonstration
Original Size: 11 x 17 inches
Medium: color markers on watercolor paper
Technique: outlining of spatial edges with black pentel after the masses were rendered and filled on broad color

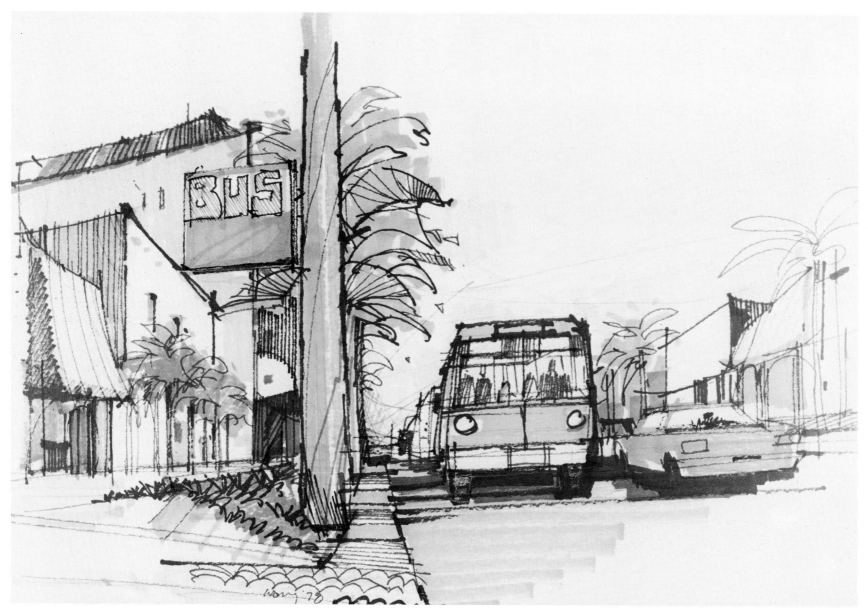

Sketching Style

Sketching is a quick graphic reflex and a highly coordinated movement between the eyes and the hands. Your hand is the final part of the sketching sequence before the image flows through the tip of the marker. The marker is merely the medium through which images are recorded. One should never blame the marker for a bad sketch. It is the hand that controls and manipulates the marker, that guides it over a blank sheet, and that carries and transmits the sketching impulses from the eyes and brain through the tools onto the sketch pad. One should frequently exercise the sketching hand by encouraging finger or wrist action. The joints of the hand should be kept loose, but they must be able to lock the wrist quickly and grip it if desired. The key word is *practice:* the more you sketch, the better the control and sense of proportion and scale you will have.

a

sketch

see

think

HOW ?

b

Picture Plane

Sketching records a three-dimensional scene onto a two-dimensional surface. Before the image is drawn, it must be temporarily captured on a hypothetical plane called the picture frame. This function is very similar to that of the camera, with which the image is recorded on film in less than a second. The picture frame is used to determine the size of the sketch and the amount of the coverage. It frames the objects that you want to sketch and blocks out the undesirable ones. The opening of the picture frame should be proportional to the paper used. Empty slide mounts are very convenient tools for framing purposes. Simply hold the mount in front of you and move it back and forth to determine how much you want to sketch. If the frame is closer to the object, the amount of coverage is reduced and the size of the object is increased. On the other hand, if the frame is closer to you, the amount of coverage increases and the size of objects becomes smaller. Most experienced artists will bypass this step not because they think that it is not necessary, but because their eyes can automatically do the cropping within the picture frame.

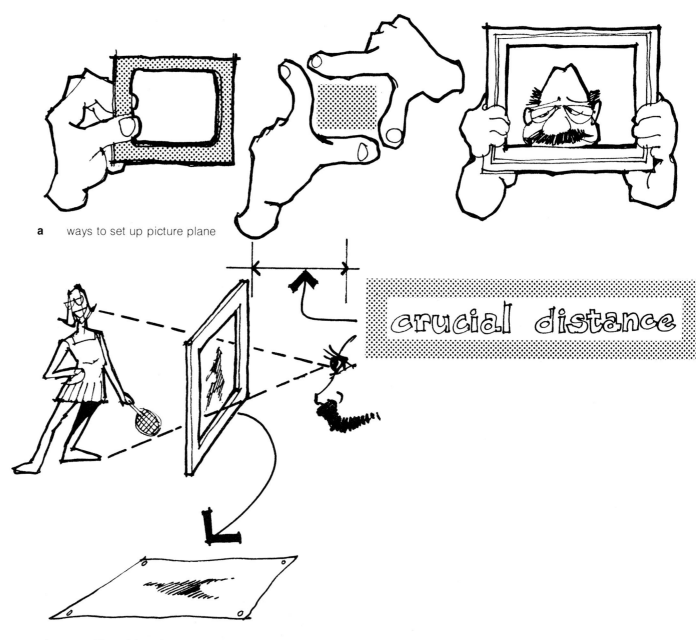

a ways to set up picture plane

crucial distance

b position of the picture plane and viewing distance

a

b

COMPOSITION

Location of the Horizon

The horizon is the eye level of the artist (viewer). The location of the horizon on the sheet will ultimately determine the location of the principal elements. It will also divide the sheet into two horizontal bands that may or may not complement each other. This horizontal division of the sheet is extremely important in the composition of a sketch.

One should avoid placing the horizon across the center of the page. It divides the sheet into two equal portions and produces a static and boring image. For the most effective composition, place the horizon at either a three-quarter or a one-quarter position. A low horizon has more sky space and tends to emphasize the verticality of objects. A high horizon is ideal for bird's-eye or oblique views. Due to the viewing angle, the depth dimension does not foreshorten as quickly as does a low horizon, so most foreground details must be included.

Positioning of the Mass

Arrange the elements in such a manner as to lead the viewer into the picture. Always position the dominant mass away from the center of the page in order to create a sense of false instability. This tends to control the eye movement of the viewer and gives the feeling that the subject is lively and not bound by the edges of the picture. The frame should be looked upon as a temporal mechanism used reluctantly to capture and suspend a moving scene for a split second. The most successful sketch is one that, although bound by the sheet, looks as if it is going to break loose.

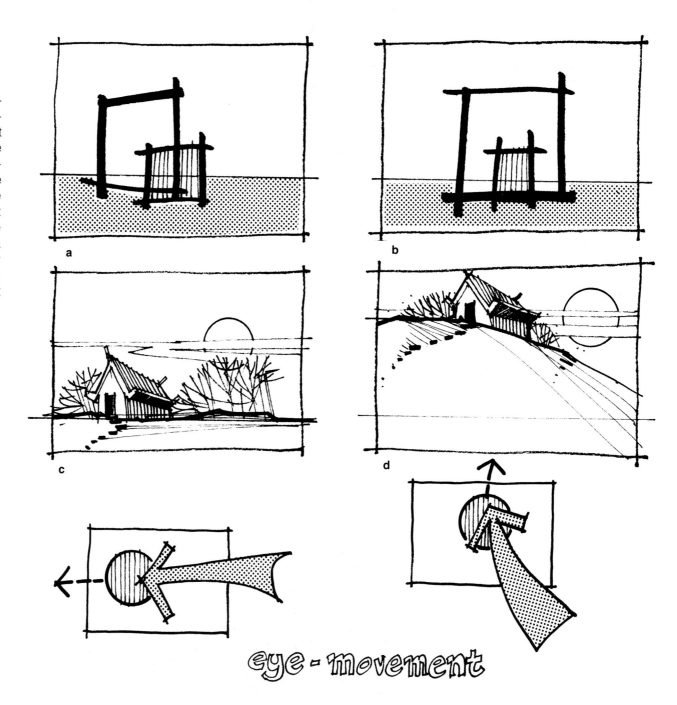

a

b

c

d

eye-movement

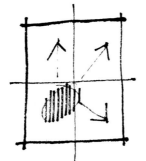

a axial balance

b occult balance

Balance

Avoid symmetrical balance. Shift the viewing position or change the sheet format to create the feeling of occult or asymmetrical balance, which is dynamic and interesting. It employs the juxtapositioning of mass and space to create a perceived but not obvious balance. The mass/space relationship is often contradictory in texture, color, and shape, but the areas should be kept relatively similar. Occult balance has a built-in system and tension and should not be misunderstood as random positioning.

c symmetrical layout

d asymmetrical layout

e horizontal format

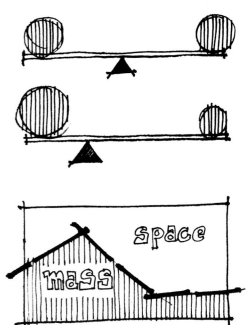

f balance between mass and space

75

SELECTION OF PERSPECTIVE

One-point Perspective

One-point perspective gives equal exposure to both sides of the lateral dimension (Figure a). Shifting the center of vision creates an uneven exposure (Figure b). This is often done to avoid a symmetrical composition for subjects to which symmetry would not be appropriate. For example, one side of a street may be more important than the other.

One-point perspective is very straightforward. It is simple and easy to understand, and such a composition encourages the use of line (streets, trees, etc.) to lead into the subject. It has a strong sense of direction, and it provides an excellent setting for the expression of repetition and rhythm.

One-point perspective is ideal for sketching street scenes and interiors.

1 pt. or 2pt. ?

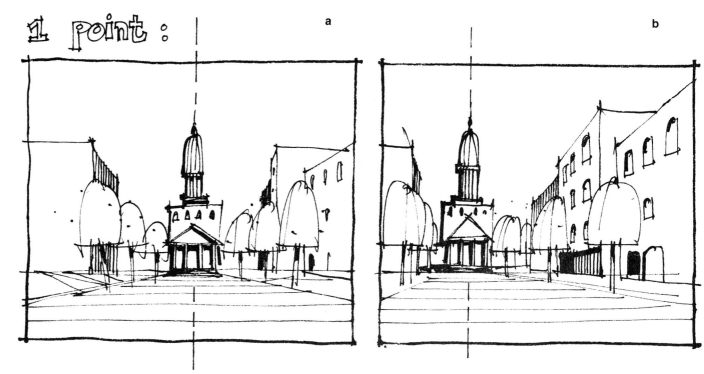

1 point :

a

b

Two-point Perspective

Two-point perspective goes beyond the frontal dimension, involving the side and back as well. It is the preferred method for expressing a complex subject. The fact that the sketch is nonfrontal creates a sharper tonal contrast between planes. It is an ideal setting for the generation of tension between subjects and thus stimulates eye movement and enlivens static statements. Avoid closeup views in two-point perspective, as they can be highly distorted and may result in a lack of continuity.

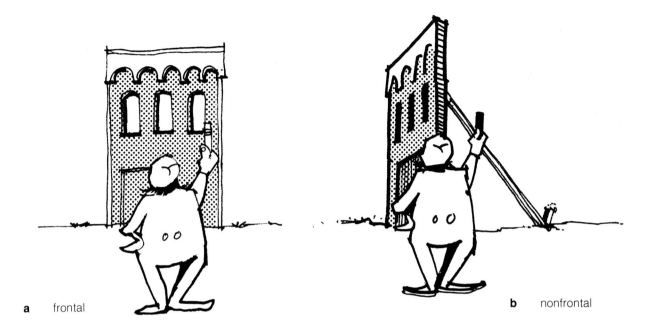

a frontal

b nonfrontal

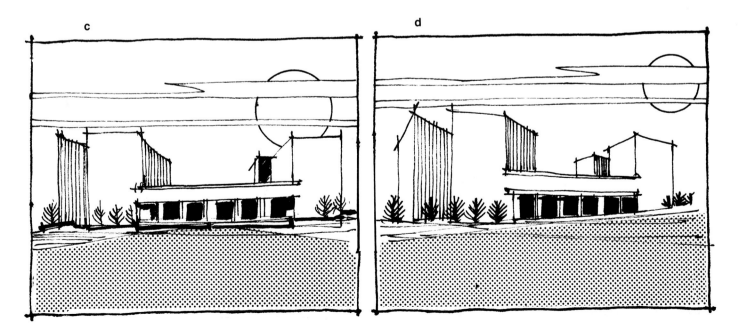

c

d

FRAMING

The four corners of the paper create dynamic interest and lead the eye away from the sheet. This situation should be corrected by reshaping the sheet with stoppers (Figure a), such as trees, bushes, rocks, human figures, or a corner of a building (Figure b). Their job is to form an edge perpendicular to the diagonal in order to prevent the eye from moving away from the point of interest. They also function as the foreground subject and they should be rendered with bold and heavy strokes and should always attempt to establish a strong tonal contrast with the rest of the picture. The position and type of stopper used should be studied carefully on thumbnail sketches (Figure c).

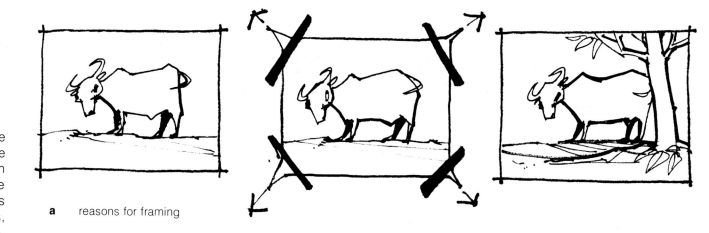

a reasons for framing

b types of framing

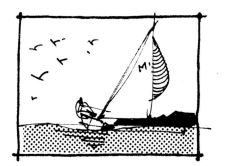

c framing exercises

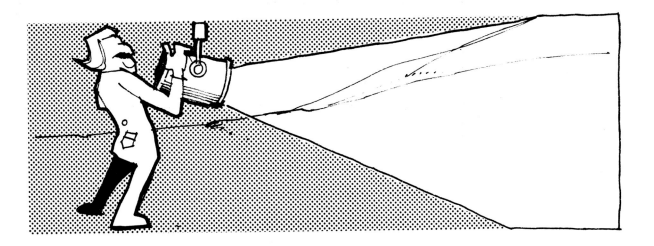

LIGHT EFFECTS

Light effects bring out the tonal contrast between planes and thus intensify the feeling of depth. They are also used to separate and classify the different layers of visual fields. For example, a house with a white roof will look sharper if it is placed in front of a dark background. Light effects are also used to define corners and spatial edges and to set a mood.

There are two kinds of realistic light sources, both with a definite direction. Natural light originates from one single source—the sun—and the light beams are parallel. Artificial light has a radiating pattern and can emanate from more than one source. In sketching, a *chiaroscuro* style can also be used. This is a pictorial representation of light, rather than a realistic interpretation of the source and its behavior. It is used in order to achieve a certain mood and atmosphere and yields an effective and abstract expression of light if done correctly.

a use of texture to differentiate the planes

b trees in background help define the shape of the roof

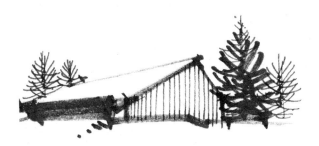

c use of zip-a-tone as background tone

d use of gray as background to bring out the contrast

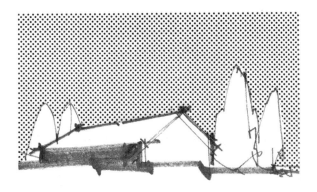

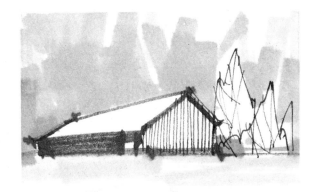

a light source from left, gray background, shaded side of building black, emphasis on the building

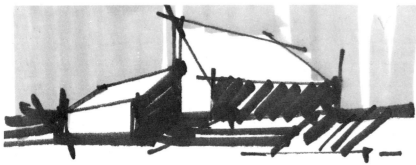

b foreground tree black, house and background light, exaggerated distance in between

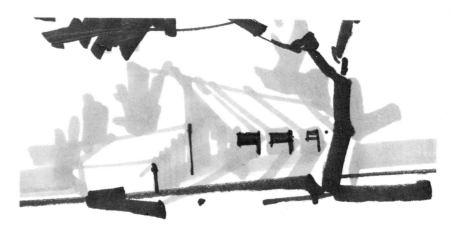

c background black, roof white, strong contrast, striking and strong mood

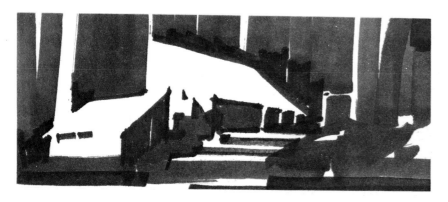

d light source not consistent, emphasis on the sculptural effect of the building creates special effect

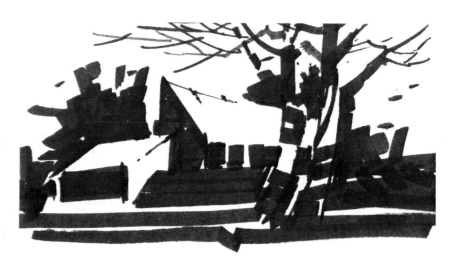

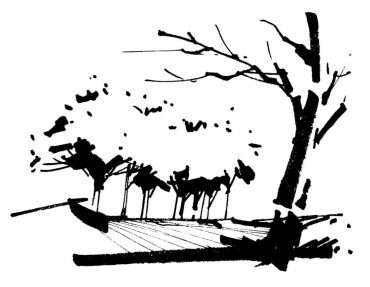

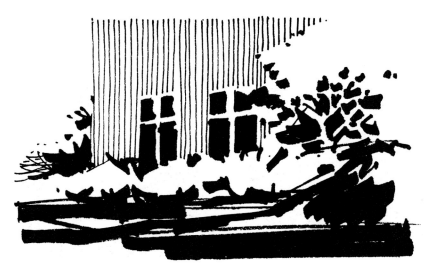

LIGHT INTENSITY

Light intensity is graphically represented by different colors or different values of one color. Its quality varies on all surfaces and sometimes even on the same surface, depending upon the position and angle of the viewer. The spot with maximum reflection usually appears to be lighter and brighter. A long, continuous surface can exhibit a variety of intensities, due to interference from other objects and texture of the surface from which the light is reflected. Three-dimensional forms should be obvious from the ways in which light and shadow fall upon them. Shadow should be used to direct eye movement. The path of light and shadow should be carried from border to border. Use strong basic shapes to define the shadow pattern. Don't attempt to capture a realistic pattern—this is the job of a camera. A sketch is not a photograph!

a dark tree canopy and shrubs in the foreground create a perfect setting for viewers to look into

b strong contrast of foliage suggests the roundness of the tree canopy

c bold and dark horizontal lines in the foreground tend to lead the eye movement, create contrasting pattern with the vertical texture on the wall

Expression of Light Effect

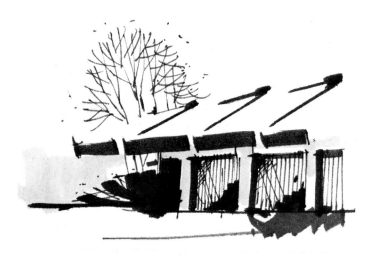

a contrast in tone emphasizes the connection between the house and the roof

b shadow of tree promotes diagonal eye movement across the page and leads viewers to the theme (house)

d brings out the sculptural effect of the product

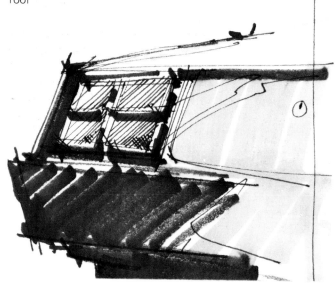

c renders details and the reflection of light

a criteria of a good sketch

captures attention

vivid

fresh

A SUCCESSFUL SKETCH

A good sketch is like a breath of fresh air. Looking at it should be an enlightening experience. The subject matter should be interesting, the composition should be appropriate and pleasing, and viewers must be able to see themselves in the picture rather than functioning merely as onlookers. The line should be forceful and should flow in a meaningful way. The strokes of the marker and the colors you use should evoke a sense of relaxation and freedom.

Sketch beyond the four borders of the sheet. Allow the lines to flow and extend beyond the page. The most unconstructive habit in sketching is to confine yourself within a fixed border. Marker movement should be fast and precise. Avoid hesitation, which can cause bleeding and uneven line width. Let the marker rotate freely at your fingertip. Acquire a good sense of scale, proportion, and perspective, and other skills will come automatically with practice.

b

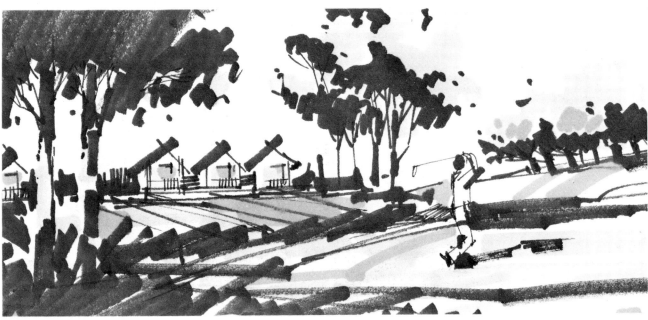

Title: Toronto Island Park
Original Size: 8½ x 11 inches
Medium: color marker on bristol board
Technique: fine branches were outlined with brown ultra-fine nib

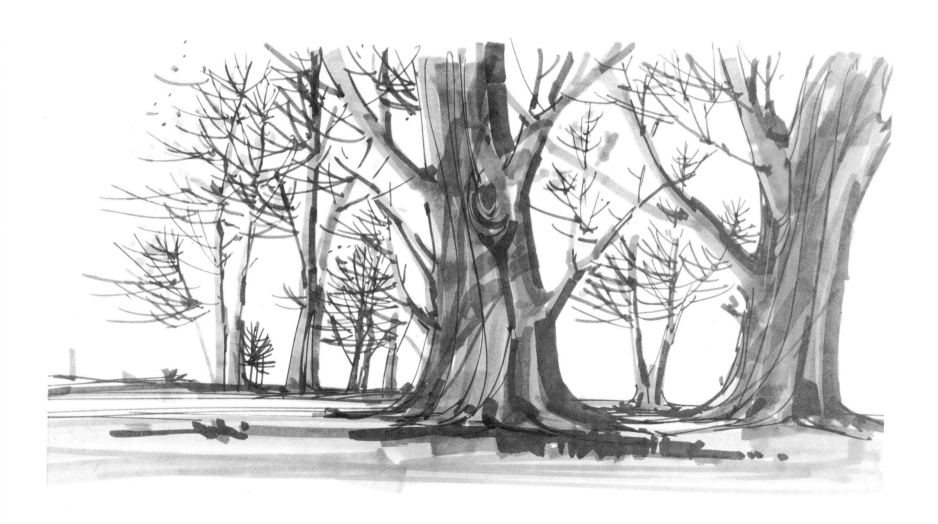

color marker on Aquabee felt-tip-marker paper

a study the perspective; identify the horizon and all the reference planes; pay attention to the change in elevation and the shift of vanishing point from the horizon to the top of the steps; lay out with pencil and a thin marker

b sketch the general outline with a Pilot razor-point marker; capture the major elements first; no details

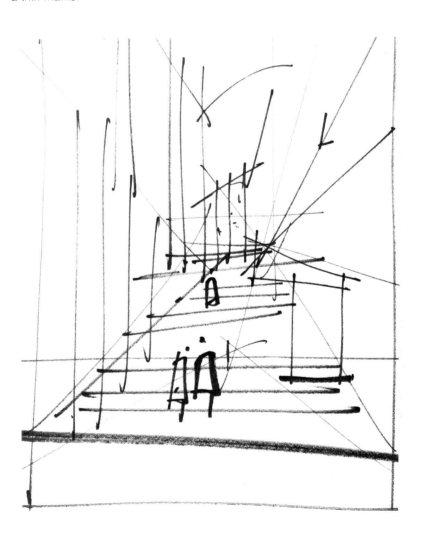

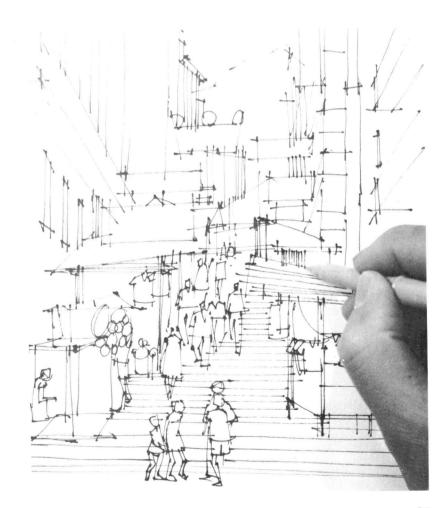

c apply the first coat of color; use
lighter colors for base, apply with broad
strokes; move quickly over the paper; and
don't worry about going over the predrawn
edges

d build up the three-dimensional
quality by applying darker values and
grays

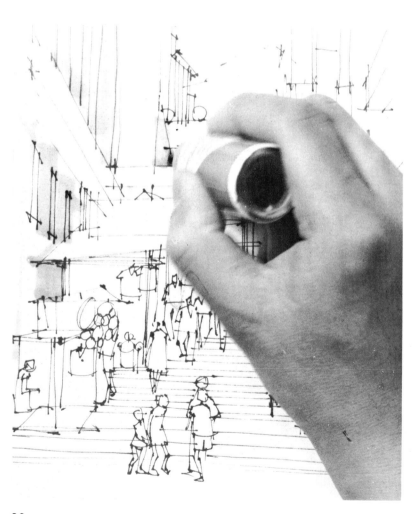

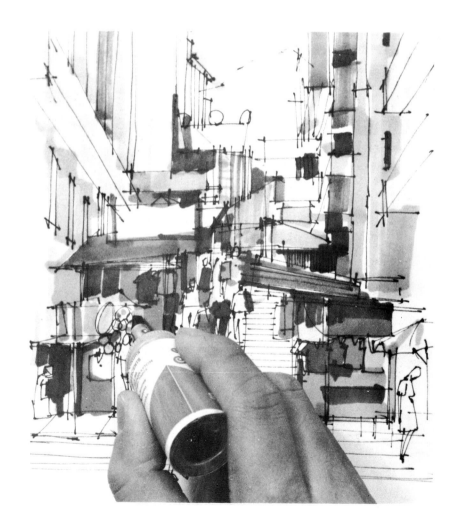

e add accent colors to people, signs, and decorative ornaments; add grays and black to the shaded sides; add shadows

f sharpen the spatial edges and details with a fine-point marker; redefine edges which may be necessary due to marker bleeding

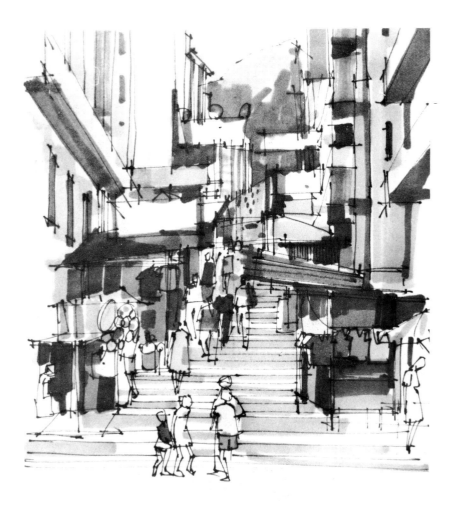

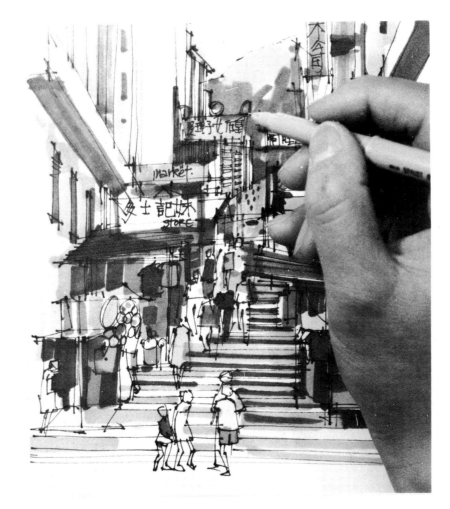

Title: Old Cairo, Egypt
Original Size: 14 x 17 inches
Medium: Eberhard Faber markers on rice
paper, watercolor
Technique: use black marker to outline the
sketch; wash with black and gray; highlight
the figure with bright color

Title: Egyptian Farm House, Cairo, Egypt
Original Size: 11 x 17 inches
Medium: Eberhard Faber on rice paper,
blacks and olive green watercolor
Technique: sketch with markers; use
broad brush strokes to fill in the spaces;
highlight the trees with light olive green

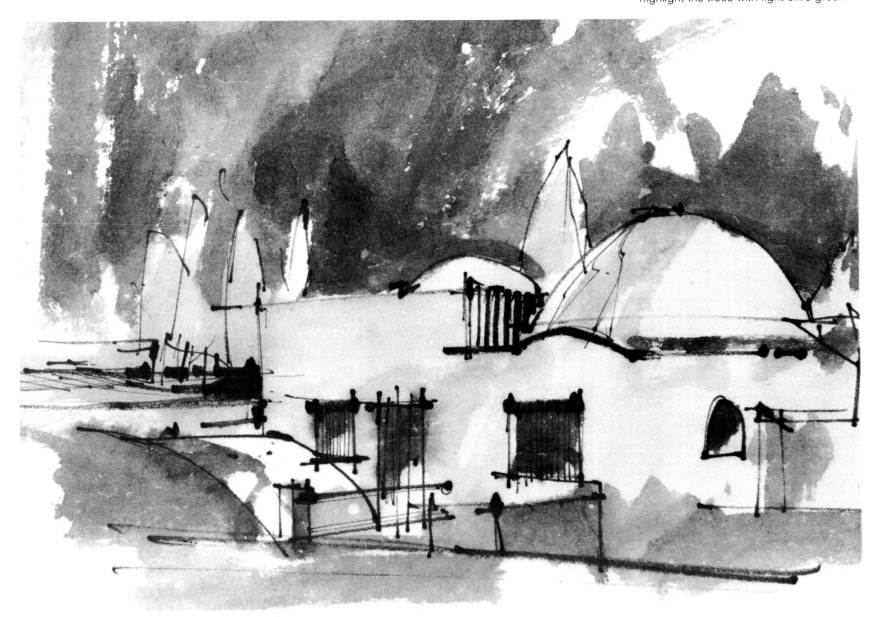

DEMONSTRATION III

Eberhard pointed-nib on rice paper

a outline the scene with quick strokes; know exactly the locations of reference planes

b hold the marker broadside to obtain thicker line width; lift the marker off the paper immediately after every stroke

c wash the sky and shaded areas with light gray ink; leave sun facing planes white; let dry

d sharpen spatial edges with the pointed-nib marker; then it's done; hands off; don't overdo it

DEMONSTRATION IV

fine-line marker, watercolor on watercolor paper

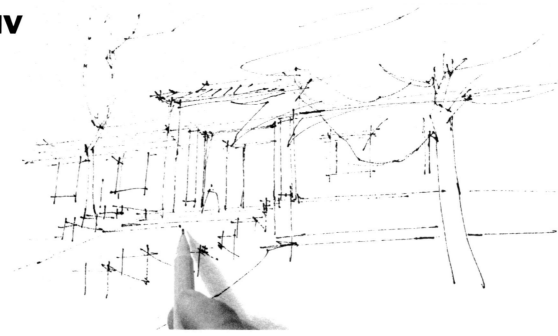

a outline the scene with a Pilot
razor-point marker; avoid details

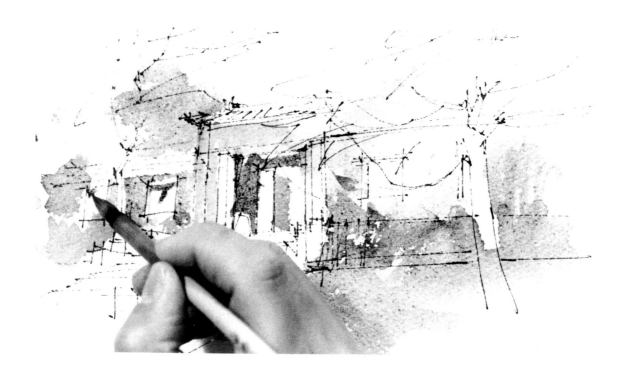

b apply watercolor; lighter colors
always go first; gradually apply darker
values after preceding coat is dried; be
patient

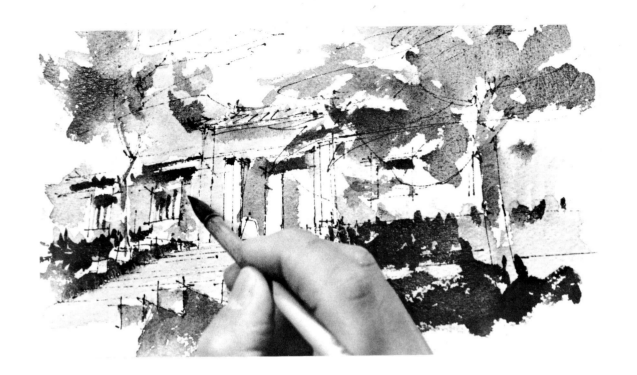

c apply darker tones to bring out the shadows and depth

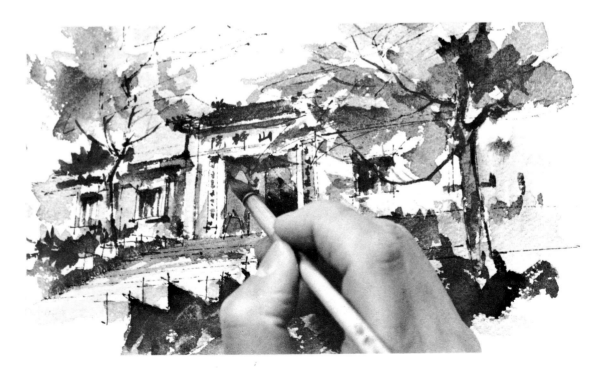

d sharpen details with a fine-point marker; add accent color (marker) for highlighting

93

Title: Tai Po Harbor, New Territories, Hong Kong
Original Size: 11 x 9 inches
Medium: Pilot fine-line marker, watercolor on watercolor paper
Technique: watercolor wash on line drawing

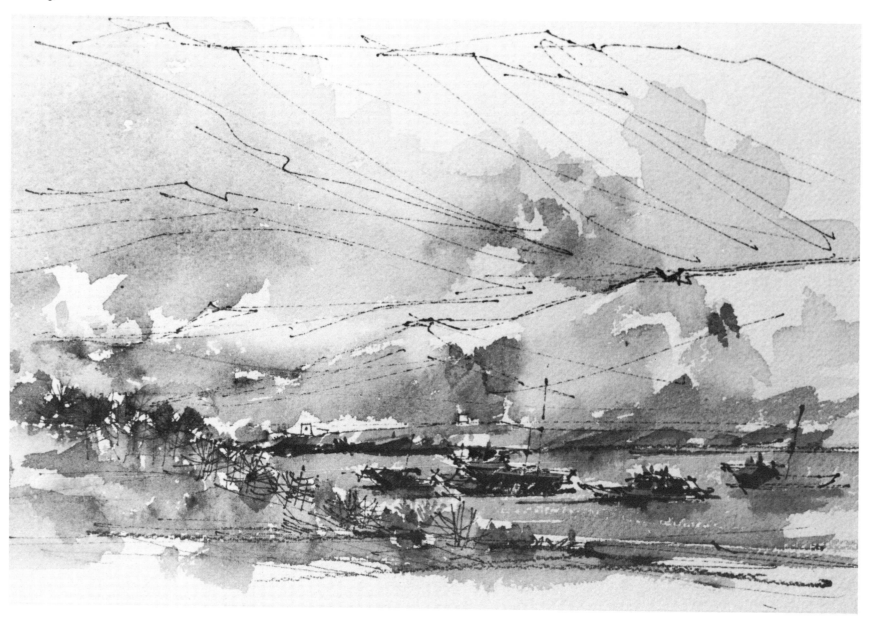

Title: Tai Po Village, New Territories, Hong Kong
Original Size: 9 x 11 inches
Medium: Pilot fine-line marker and watercolor on watercolor paper
Technique: Watercolor wash on line drawing, heavy black line drawn with Eberhard Faber pointed nib

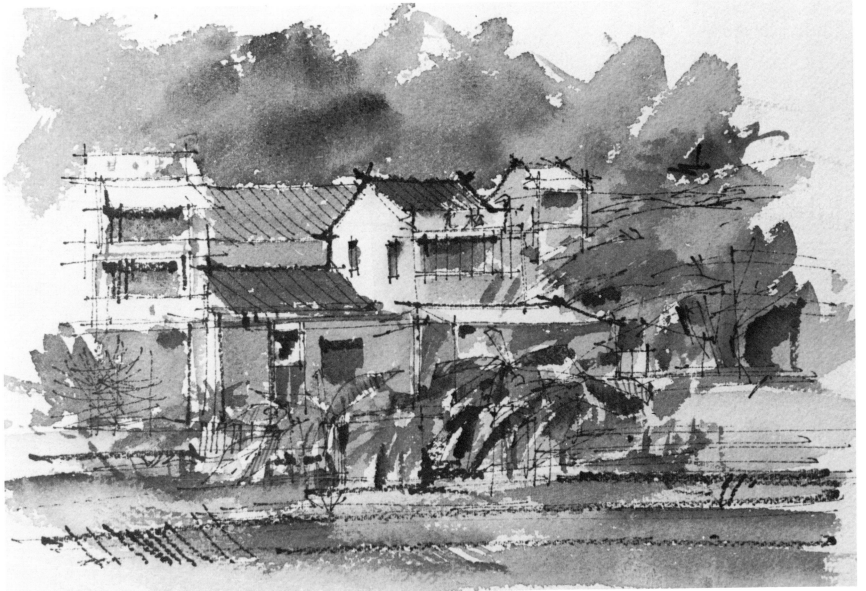

Title: studio demonstration
Original Size: 11 x 17 inches
Medium: color marker on watercolor paper
Technique: Eberhard Faber pointed-nib marker used to outline important spatial edges

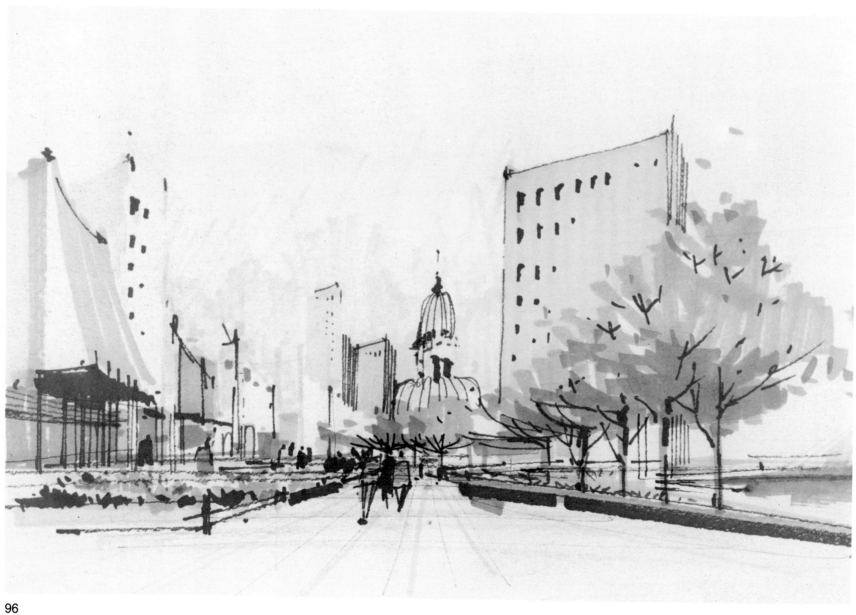

Title: Downtown
Original Size: 11 x 9 inches
Medium: color marker on watercolor paper
Technique: broad marker strokes

Title: House in Sausalito
Original Size: 11 x 14 inches
Medium: color marker on watercolor paper
Technique: broad marker strokes

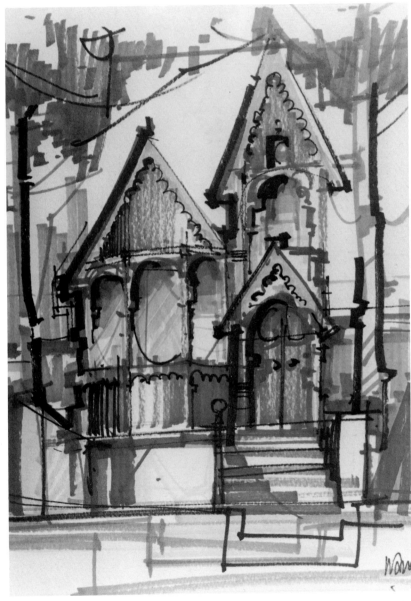

Title: Queechee Lake, Vermont
Original Size: 9 x 11 inches
Medium: black and gray marker on bristol
board
Technique: broad strokes

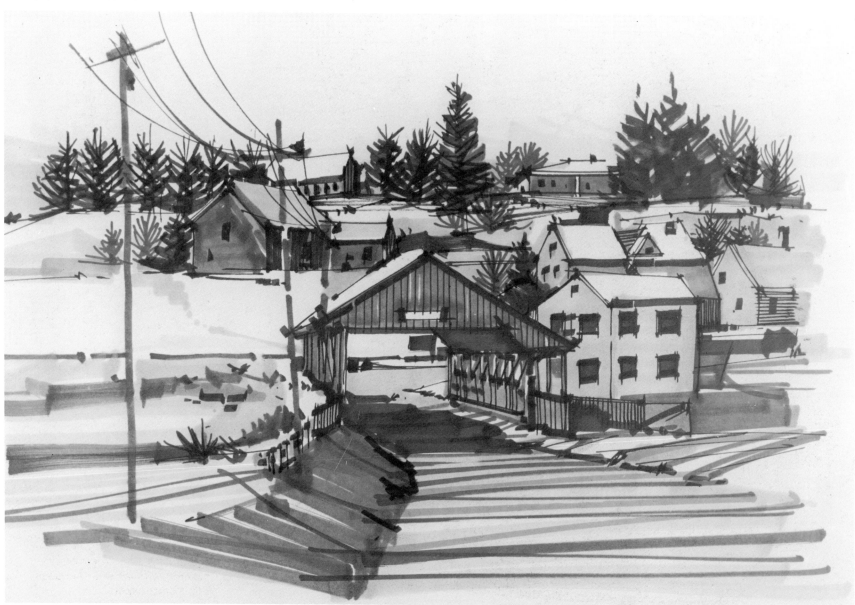

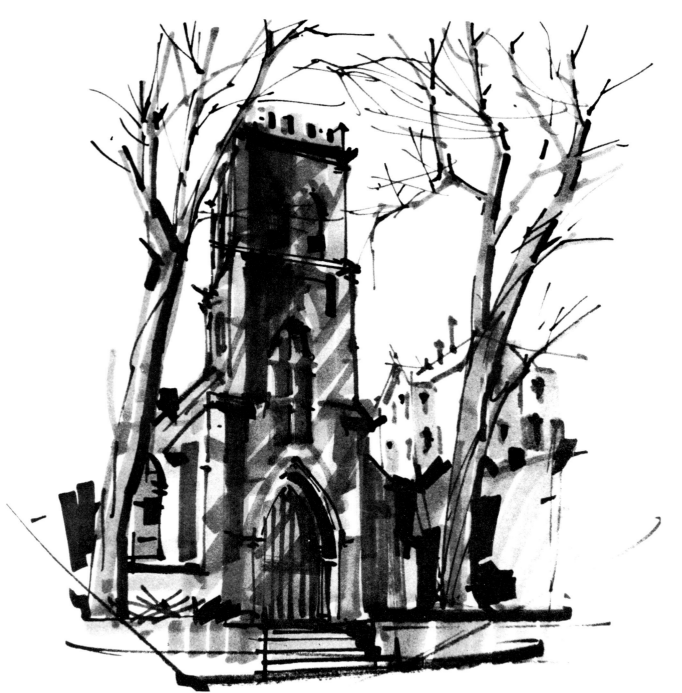

Title: Church in Galina, Illinois
Original Size: 11 x 14 inches
Medium: color marker on Aquabee
felt-tip-marker paper
Technique: broad strokes

Title: Church in Madison, Wisconsin
Original Size: 11 x 14 inches
Medium: color marker on Aquabee
felt-tip-marker paper
Technique: broad strokes

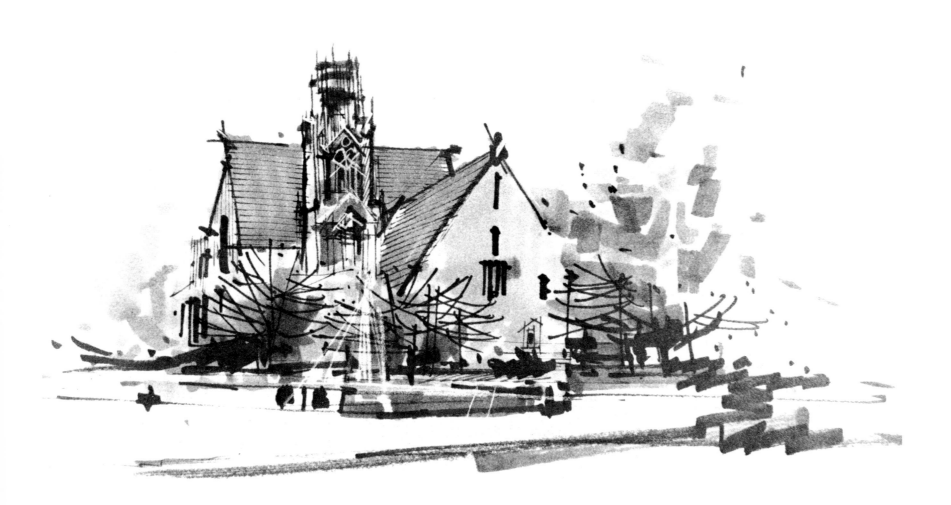

Title: Railroad Station, Easton, Massachusetts
Original Size: 11 x 14 inches
Medium: color marker on Aquabee felt-tip-marker paper
Technique: broad strokes

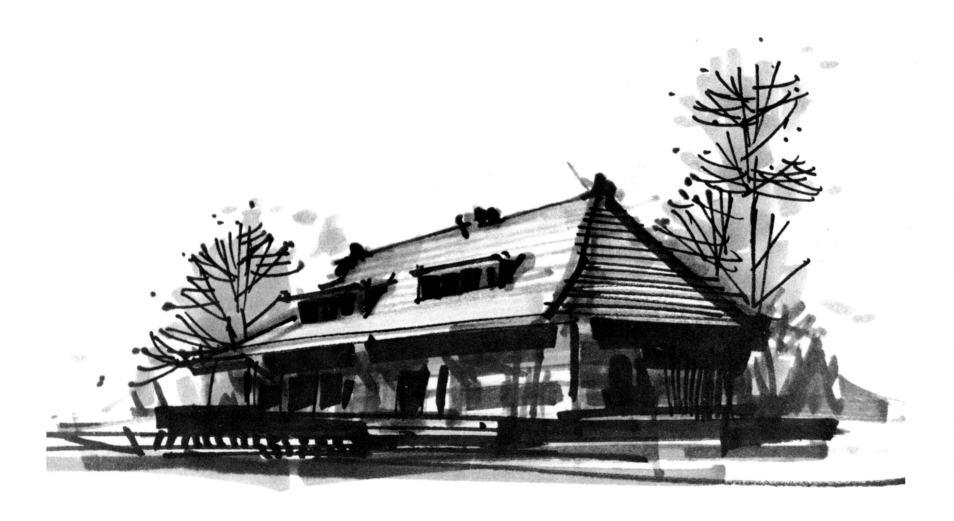

REFERENCES

Borgman, Harry. *Drawing With Ink.*
New York: Watson-Cuptill
Publications, 1977.

Choate, Chris. *Architectural
Presentation in Opaque Watercolors.*
New York: Reinhold Publishing, 1961.

Haak, B. *Rembrandt Drawings.* New
York: The Overlook Press, 1976.

Hank, Kurt and Belliston, Larry. *Draw.*
Los Altos, California: William
Kaufmann, Inc., 1977.

Hartmann, Robert. *Graphics for
Designers.* Ames, Iowa: Iowa State
University Press, 1976.

Mugnaini, Joseph. *The Hidden
Dimension of Drawing.* New York: Van
Nostrand Reinhold Company, 1974.

Palmer, Frederick. *Visual Awareness.*
London: B. T. Batsford, Ltd., 1972.

Panofsky, Erwin. *Studies in Iconology.*
New York: Harper & Row, Publishers,
Inc., 1962.

Pitz, Henry C. *Sketching With the Felt
Tip Pen.* New York: Studio
Publications, Inc., 1959.

Sze, Mai-mai. *The Mustard Seed
Garden Manual of Painting.* Princeton,
N.J.: Princeton-Bollingen, 1956.

Waring, Richard. *Drawing With
Markers.* Watson-Cuptill Publications,
1974.

Watson, Ernest and Aldren. *The
Watson Drawing Books.* New York:
Reinhold Publishing, 1962.

INDEX